MW00618911

INDIANA'S
LOST SPEEDWAYS
AND
LEGENDARY DRIVERS

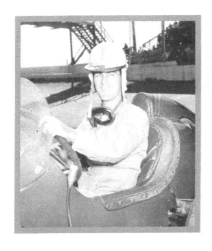

David Humphrey with the Indiana Racing Memorial Association
Introduction by Mark L. Eutsler

ARCADIA
PUBLISHING

Published by Arcadia Publishing
Charleston, South Carolina

Library of Congress Control Number: 2020951414

For all general information, please contact Arcadia Publishing:
Telephone 843-853-2070
Fax 843-853-0044
E-mail sales@arcadiapublishing.com
For customer service and orders:
Toll-Free 1-888-313-2665

Visit us on the Internet at www.arcadiapublishing.com

Dedicated to Warren Brinson, a true Hoosier race fan.

CONTENTS

ACKNOWLEDGMENTS

I would like to thank the following people and organizations who contributed to this book: Alexandria Historical Society, Anderson Public Library, Anderson Speedway, Jeff Bale, Brooks Townsend, Roger Rinker, Julie Rinker Mitchell, Randy Malsom, Wayne County Historical Museum, Indiana Historical Society, Indiana State Archives, Gene Crucean, Wayne Bryant family, Brian Wilcox, Sam Mudd, Indianapolis Motor Speedway, Indiana Racing Memorial Association, and the countless number of individuals, libraries, and museums who also assisted. Special thanks to Mark Eutsler for writing the introduction.

INTRODUCTION

Indiana, speed, and racing are almost synonymous. In 1903, the first automobile to record 60-mph speeds did so on the one-mile oval track at the Indiana State Fairgrounds. The automobile was driven by Barney Oldfield. The Montpelier Motor Speedway in eastern Indiana opened to horse racing in 1903 and switched to auto racing in 1915. The 37-degree banked asphalt-surfaced Winchester Speedway opened in 1916 and quickly earned a reputation as "The World's Fastest Half Mile." Tracks to follow included Salem Speedway in 1947, the Terre Haute Action Track in the 1950s, and Tri-State Speedway near Haubstadt in 1957. Many Indy 500 starters and some winners raced throughout Indiana as they built their careers.

The "Motorsports Industry in the Indianapolis Region Study" that was commissioned in 2004 by The Indy Partnership, Indianapolis Economic Development, Hendricks County Economic Development Partnership, Corporation for Economic Development–Madison County, and the Indianapolis Motor Speedway Foundation affirmed that "throughout the world, Indianapolis is most recognized as the racing capital of the world and home of the Indianapolis 500."

It is estimated that more than 400 motorsports-related companies are doing business in Indiana with an approximated workforce of 8,800 individuals working full time in jobs directly related to motorsports. Estimated motorsports-related wages total more than $425 million annually.

Racing has been embraced by community organizations like the 500 Festival. Founded in 1957, its mission is to produce life-enriching events and programs that celebrate the spirit and legacy of the Indianapolis 500. The festival fosters a positive impact on the city of Indianapolis and state of Indiana. Its economic impact is around $21 million each year. Founded in 1920, the Citizens' Speedway Committee has raised Indy 500 incentive awards through its Lap Prize Program for a century.

According to a study commissioned by the Indianapolis Motor Speedway in 2000, the Indy 500 produces an economic impact of $336 million each year. NTT INDYCAR CEO Mark Miles has said, "It's like having a Super Bowl in town every year—and we don't have to bid on it."

From tracks to drivers, mechanics, crew members, writers, and photographers—racing is all about the people who love it and the common bond they share. I quickly discovered this when I cofounded the Indiana Racing Memorial Association and its national counterpart, the American Racing Memorial Association.

When the 60th anniversary of the 1954 plane crash that claimed the lives of Ray Grimes, Ernest Roos, and Wilbur Shaw was approaching, I had a conversation with my friend from college and colleague through the years, former state representative Brian Hasler.

I told Brian I had a desire to observe the occasion, perhaps with an appropriate gravestone-like marker near the crash site on the east edge of Peterson, Indiana, just west of Decatur. Brian though it was a great idea and quickly noted that Indiana was rich with sites, events, and people involved with racing, yesterday and today.

That conversation in his living room quickly turned into an effort, an organization, and tangible results. In December 2013, the organizational meeting of the Indiana Racing Memorial Association (IRMA) was held at INDYCAR corporate headquarters across the street from the Indianapolis Motor Speedway, and IRMA's Historic Marker Legacy Program was begun as one way to achieve

the group's mission "Celebrating Indiana's Racing Heritage." IRMA's first marker was unveiled on the 100th anniversary of Winchester Speedway. The date was July 4, 2014. On October 30 that year, a ceremony was held at the plane crash site, and two days later, a marker for Wilbur Shaw was unveiled at the Shelby County Fairgrounds, where he famously raced in a goat-drawn cart.

Such was the case in North Vernon, Indiana, and the marker for Pat O'Connor, who adorns the cover of this book. Crawfordsville mayor Todd Barton provided funds for the Howdy Wilcox marker. The Tippecanoe County commissioners and Lafayette mayor Tony Roswarski funded the marker honoring 1927 Indy 500 rookie winner George Souders and Roscoe Sarles. Lebanon mayor Matthew Gentry supported the marker honoring Don and Mel Kenyon. It was unveiled on Mel's birthday, April 15, in 2018.

More than 1,000 people were on hand at the 2016 Jungle Park Reunion, north of Bloomingdale, Indiana, when a marker honoring Jungle Park Speedway was unveiled. IRMA coordinated a reunion two years later with the same attendance.

In partnership with Indianapolis Crown Hill Cemetery, IRMA coordinated medallions to be placed on grave sites of the 60-plus racing legends interred there. A web-based walking/driving tour is on tap to be introduced in 2021. With a $10,000 gift from Chevy Motorsports, the Chevrolet family grave site at Holy Cross and St. Joseph Cemetery, south of downtown Indianapolis, received a new stone.

Although I live just 45 minutes from the Indianapolis Motor Speedway in the town of Linden in west central Indiana, my journey as a fan can trace its roots 4,000 miles away to Whitehorse, Yukon, Canada.

I have been to 56 consecutive Indy 500s and 115 consecutive races at the Indianapolis Motor Speedway. One of my favorite activities is presenting my experiences to fourth grade classes each spring. Indiana history is taught in fourth grade and several go to the Indianapolis Motor Speedway and 500 Festival Education programs at the track during practice days in May. I love seeing the excitement in the fourth graders. It reminds me not to take for granted that I can go to the track whenever I want. For many, who come from all parts of the world, it is a once in a lifetime experience.

When I was speaking at the unveiling of a marker honoring Ray Harroun in Anderson, Indiana, I said, "Indiana students learn that Ray Harroun won the first Indy 500 before they learn that George Washington was our first president."

While that was said in humor, I believe it epitomizes how a lot of us feel about racing. We love it! As the second "Voice of the 500" Paul Page said about the 500—and it applies to all racing— "It's a kaleidoscope of sound, color, and emotion." It draws you in, you don't want to be anywhere else, and, when it's over, you can't wait for the next race.

Now we don't have to wait for the next race! Thanks to David Humphrey's *Indiana's Lost Speedways and Legendary Drivers*, we can relive memories, refire passions, and reflect on why, as Jim Phillippe used to say announcing "Taps" before the start of the Indy 500, racing is "the world's most spectacular spectator sport." Enjoy!

—Mark L. Eutsler, PhD
Cofounder, Indiana Racing Memorial Association and
American Racing Memorial Association

ANDERSON
SOAP BOX DERBY

Maurice Bale Jr. is all smiles after winning the All-American Soap Box Derby held in Akron, Ohio. The 13-year-old Anderson youth drove his Anderson Newspapers Inc.–sponsored car to a first-place finish on August 11, 1935. A crowd estimated at between 75,000 to 90,000 people attended the prestigious racing event. Bale received many awards for being crowned National Soap Box Derby champion, including a four-year scholarship from Chevrolet valued at $2,000. (Courtesy of Don Bale.)

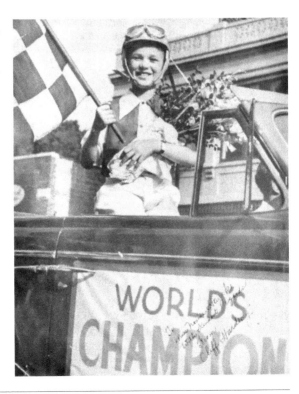

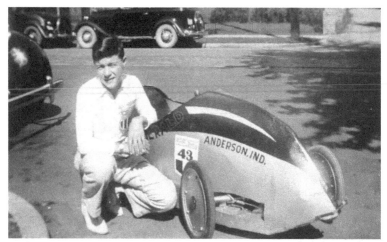

Maurice Bale Jr. poses for a photograph outside his Anderson home. His No. 43 winning derby car is on display at the Soap Box Derby Hall of Fame Museum in Akron, Ohio. (Courtesy of Don Bale.)

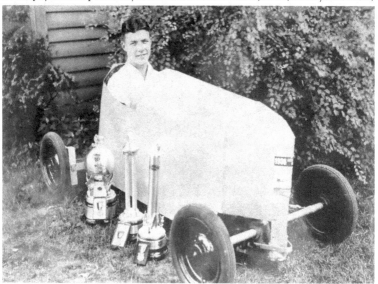

Surrounded by trophies won at numerous Soap Box Derby events, Maurice Bale Jr. sits in his 1936 derby car. That same year, Bale finished first for the second year in a row at the Anderson Soap Box Derby. (Courtesy of Don Bale.)

NATIONAL SOAP BOX DERBY CROWNS MAURICE BALE AS U. S. BOY SPEED CHAMPION

AKRON, Ohio, Aug. 12—(Special to The Anderson Herald) While 100,000 persons cheered themselves hoarse, Maurice E. Bale, Jr., 13 of Anderson flashed across the finish line in first place in the national finals of the all American Soap Box Derby here yesterday, thereby clinching the Junior Speed Championship of the United States. His

victory entitles him to the four year university scholarship offered by the Chevrolet Motor Company, in addition to other coveted awards.

Winner Brings Home Trophies Of Derby

Anderson Boy Tells Of Thrills In Racing To Lead Before Crowd Of Notable Guests

Maurice, the son of Mr. and Mrs. Anderson, entered the race under sponsorship of The Anderson Herald and the Hunter Chevrolet agency whose local race he carried off a few weeks ago, winning in a field of 136 entries. The race here

Anderson Newspapers Inc. featured Maurice Bale Jr. on its front page after he was crowned champion at the National Soap Box Derby. The article ran on August 15, 1935. Several Indiana newspapers printed stories about the Anderson teenager's accomplishments in Akron, Ohio. (Courtesy of Don Bale.)

This All-American Soap Box Derby program is one of many archival materials owned by the Maurice Bale Jr. family. After Maurice's days of competing at Soap Box Derby events came to an end, he remained actively involved with the Anderson Soap Box Derby, helping youngsters build cars and volunteering at Anderson's Derby Downs. Bale graduated from Purdue University and worked as an engineer at Delco-Remy for 36 years. The 1935 National Soap Box Derby champion passed away on March 12, 1994, at the age of 72. (Courtesy of Don Bale.)

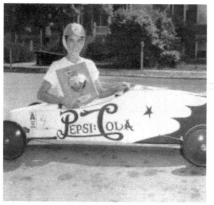

Brooks Townsend took home first-place honors at the 1955 Anderson Soap Box Derby. Townsend is shown sitting in his Pepsi-Cola–sponsored derby car holding his championship trophy. Townsend was a student at Anderson High School when he won the Anderson Soap Box Derby. He went on to serve as director of the Anderson Soap Box Derby from 1965 through the late 1970s and regional director of the All-American Soap Box Derby in 1981 and 1982. In 2008, Townsend was inducted into the Soap Box Derby Hall of Fame. (Courtesy of Brooks Townsend.)

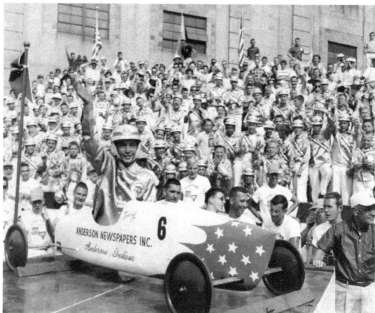

Terry Townsend waves to the crowd after winning the 1957 All-American Soap Box Derby in Akron, Ohio. The 14-year-old Anderson youth drove his Pepsi-Cola–sponsored derby car to victory in Anderson to qualify for the national competition in Akron. However, the Akron National rules required that the Pepsi-Cola sponsorship be removed from Townsend's derby car and replaced with Anderson Newspapers Inc., which sponsored the Anderson race. (Courtesy of Brooks Townsend.)

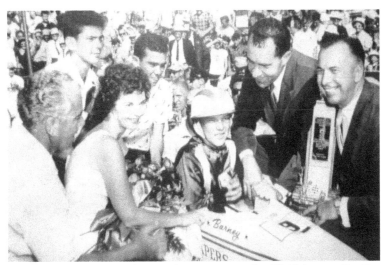

Barney Townsend celebrates in the victory lane after winning the 1959 All-American Soap Box Derby. Joining the 13-year-old champion are members of the Townsend family and Vice Pres. Richard Nixon. For many years, the Townsend name was synonymous with the Anderson Soap Box Derby due to the family's dedication to the race. Therefore, in 1994, Anderson Derby Downs was renamed Townsend Hill. (Courtesy of Brooks Townsend.)

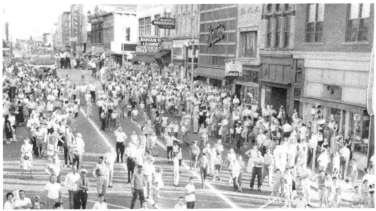

A large crowd gathered in downtown Anderson in the late 1950s to watch the Soap Box Derby race. By 1962, Woody Townsend and Denny Weatherford had built a track for the young racers on North Madison Avenue that became home to the Anderson Soap Box Derby. (Courtesy of Brooks Townsend.)

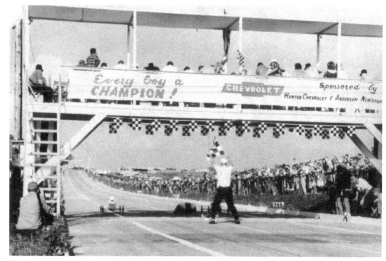

The checkered flag waves as the winner of this heat crosses the finish line at the 1965 Anderson Soap Box Derby. Printed on the banner on the catwalk near the end of the 954-foot hill are the words "Every Boy a Champion!" It would be another six years before a female would compete in the Anderson Soap Box Derby. (Courtesy of Brooks Townsend.)

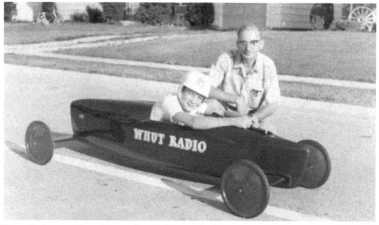

Roger Rinker poses for a photograph in his WHUT Radio–sponsored derby car outside his family's home in Anderson. To the right is his father, Mac Rinker, who assisted in building the car. As is the case with many parents, Mac was involved in the Anderson Soap Box Derby for several years. (Courtesy of Roger Rinker.)

Roger Rinker holds his championship trophy after winning the 1967 Anderson Soap Box Derby. With Rinker are his sister Susan and his father, Mac. To this day, Roger proudly displays the coveted trophy alongside other awards in his Anderson home. Rinker graduated from Madison Heights High School in 1972 and is a General Motors retiree. (Courtesy of Roger Rinker.)

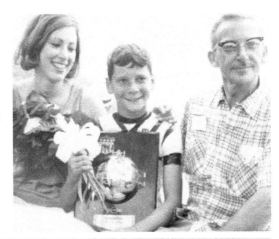

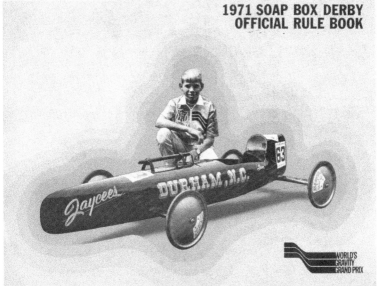

In 1971, Julie Rinker was one of the first females to compete in the Anderson Soap Box Derby. The 14-year-old self-proclaimed tomboy desired to race Soap Box Derby cars along with her brothers Roger and Gary. Julie finished in eighth place in her division, followed by a fourth-place finish in 1972. Julie kept several items from her inaugural race, including this Soap Box Derby Official Rule Book. (Courtesy of Julie Rinker Mitchell.)

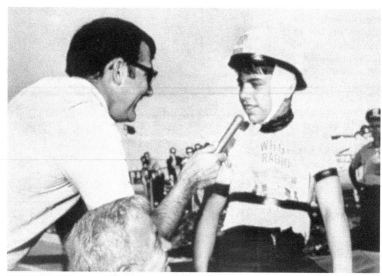

WHUT Radio reporter Jay Benoit is shown interviewing Randy Malsom after the 12-year-old Anderson youth won the 1968 Anderson Soap Box Derby. Malsom's derby car sponsor was WHUT Radio, a popular AM station in Anderson. (Courtesy of Randy Malsom.)

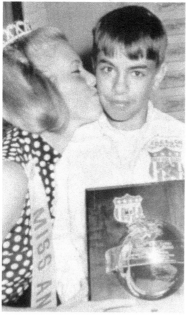

With trophy in hand, Randy Malsom receives a kiss on the cheek from Jeanne Sitz, Miss Anderson 1968. At the All-American Soap Box Derby, Malsom raced down the hill twice, winning the first heat. (Courtesy of Randy Malsom.)

ARMSCAMP SPEEDWAY

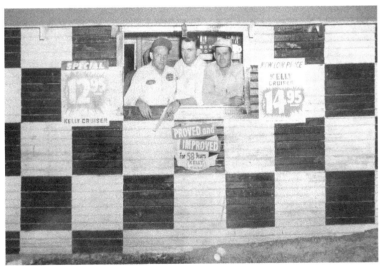

In this c. 1952 image, Employees of Kelly Tire greet patrons in a checkered flag–painted stand at Armscamp Speedway in Alexandria. These men sold and promoted Kelly Cruiser tires priced at $12.95 and $14.95. Kelly Tire was established in 1894 in Springfield, Ohio, and is the oldest American tire brand. (Courtesy of Alexandria Historical Society.)

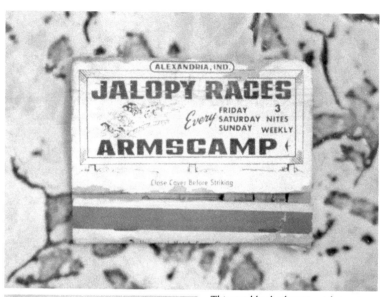

This matchbook advertising jalopy races at Armscamp Speedway dates back to the early 1950s. The races were held every Thursday, Friday, and Saturday night at the popular racetrack located off State Road 28 in Alexandria. (Courtesy of Alexandria Historical Society.)

Armscamp Speedway programs sold during the World War II era were priced at 10¢ each. This particular program promoted Victory bonds that were first introduced on May 1, 1941, to help war efforts overseas. The last proceeds from Victory bond campaigns were deposited to the US Treasury on January 3, 1946. (Courtesy of Alexandria Historical Society.)

Stan Smola of Fort Wayne competed in dozens of races throughout central Indiana and the Midwest. On July 19, 1947, Smola was critically injured in an accident at Armscamp Speedway; however, he recovered from his injuries. Smola is shown in this 1948 photograph when he served as Armscamp Speedway's flagman. (Courtesy of Alexandria Historical Society.)

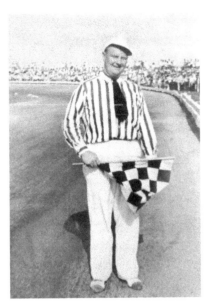

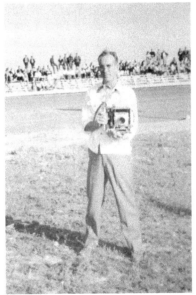

Alexandria native Orville C. Wright was a part-time photographer for United Press International for 14 years, covering races in Daytona Beach, Indianapolis, and central Indiana. Wright is shown holding his camera on race night at Armscamp Speedway in 1948. Wright died from a sudden illness on July 3, 1985, at the age of 67. (Courtesy of Alexandria Historical Society.)

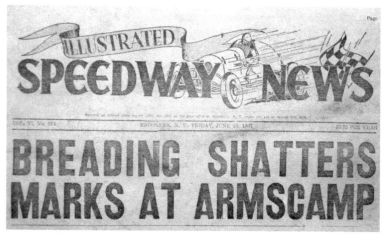

Bob Breading made the front-page news on the June 13, 1947, edition of the *Illustrated Speedway News*, a racing newspaper published in Brooklyn, New York. During his appearance at Armscamp Speedway, Breading set new track records in the first heat (2:34), semifinal heat (3:47), and the feature race (6:22). Over 6,000 fans were in attendance at the race that also featured drivers Gene Force and Dick Frazier. (Courtesy of Alexandria Historical Society.)

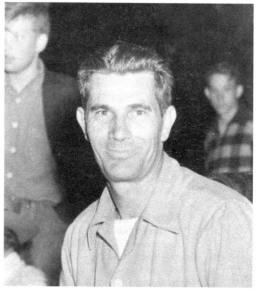

Bob Breading won his first of three Consolidated Midget Racing Association titles in 1946. The Indianapolis-born race driver earned $14,000 that year, spending half of his winnings on car repairs and travel. Breading is pictured before competing in a race at Armscamp Speedway. He is considered to be one of the best midget race car drivers of all time, winning titles in Texas, Indiana, Illinois, Michigan, and California. (Courtesy of Alexandria Historical Society.)

During his years of racing in the AAA/USAC Championship Car Series, Frank Tillman accumulated no wins, but he fared much better at Armscamp Speedway and the Kokomo Speedway. After winning a 15-lap race at the Indianapolis Speedrome in August 1947, Tillman was involved in a four-car crash later that evening. The Indiana native received head and neck injuries in the pileup but continued with his racing career after recovering from the accident. (Courtesy of Alexandria Historical Society.)

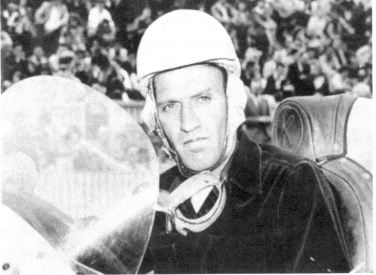

Indiana-born Swede Carpenter posed for this photograph prior to a 25-lap feature race at Armscamp Speedway that he won on April 14, 1946. That same year, Carpenter was featured on the cover of the Indianapolis Midget Speedway program, which sold for 15¢. Carpenter was the leading scorer in the Consolidated Midget Racing Association when he raced on opening night at the Sportsdrome Speedway in Jeffersonville, Indiana, on August 28, 1948. (Courtesy of Alexandria Historical Society.)

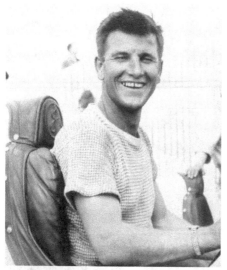

Kenny Eaton was a man who wore many hats. The Lewisville, Indiana, native owned a grocery store and an apple orchard, sold real estate, and served his country in World War II in Europe and the Pacific. But race fans remember Eaton as a regular driver on paved and dirt ovals from the late 1940s to the mid-1950s, including appearances at Armscamp Speedway. Eaton raced for three years on the AAA/USAC Champ Car Series, winning $626. He attempted to qualify for the Indianapolis 500 in 1950 and 1951 but failed to make the race. Eaton died unexpectedly in 1980 at the age of 64 while vacationing in Florida. (Courtesy of Alexandria Historical Society.)

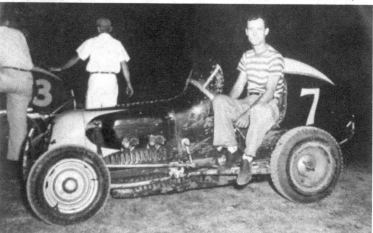

Woodrow Wilson "Woody" Campbell sits on his No. 7 midget racer at Armscamp Speedway. From 1936 through the 1950s, Campbell competed in American Automotive Association (AAA) midget races throughout central Indiana, with wins at Armscamp Speedway during the late 1940s and early 1950s. Campbell was a crowd favorite at Richmond Midget Stadium, located in his hometown of Richmond, Indiana, where he was born on April 6, 1917, and died on March 11, 1999. (Courtesy of Alexandria Historical Society.)

ARMSCAMP SPEEDWAY

Bill Holloway was one of the most successful and popular drivers at Armscamp Speedway, and according to his official website, it was his favorite track to race. In 1952 and 1953, Holloway compiled over 40 feature wins while setting many track records. One of Holloway's most memorable wins took place at Sun Valley Speedway in Anderson. In 1955, Holloway competed in the 300-lap National Crown Event, driving his 1934 Ford Coupe to the victory lane. Holloway retired from racing in 1974 and passed away in 2011 at the age of 77. (Courtesy of Todd Holloway.)

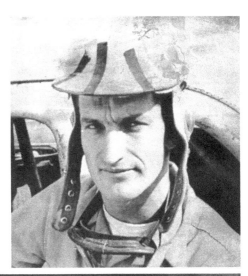

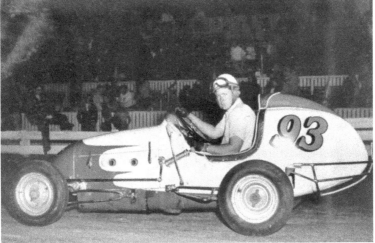

Lloyd Ruby is mostly known for driving in 18 Indianapolis 500 races, where he finished seven times in the top ten and twice in the top five. But he also raced midget and Formula One cars and twice won 24 Hours of Daytona with his partner Ken Miles. The popular driver posed for this photograph at Armscamp Speedway in the late 1940s. Ruby was referred to as the "Rail Rider" by the *Kokomo Tribune* on July 30, 1948, in an advertisement promoting a race at Armscamp Speedway. (Courtesy of Alexandria Historical Society.)

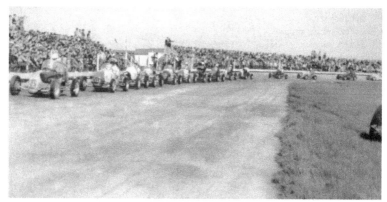

Drivers head down the straightaway single-file at Armscamp Speedway during a midget race held on April 18, 1948. Armscamp Speedway hosted hundreds of races from 1941 to 1967, with automobiles ranging from jalopies and midget and sprint cars to the popular Figure 8. A fire broke out in September 1946 and caused $20,000 in damages to the grandstand area. When the track reopened two weeks later, over 5,000 spectators were in attendance. In the mid-1960s, Armscamp Speedway hosted the Little 500 Bicycle Derby and held its last race in the summer of 1967. (Courtesy of Alexandria Historical Society.)

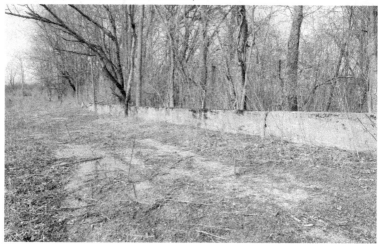

This outer wall marking the track's main straightaway is all that remains of Armscamp Speedway. The quarter-mile asphalt oval track and eighth-mile infield track are filled with overgrown weeds and 50-year-old trees. However, die-hard race fans make the pilgrimage to Armscamp Speedway by the hundreds year after year. (Photograph by David Humphrey.)

RICHMOND RACING

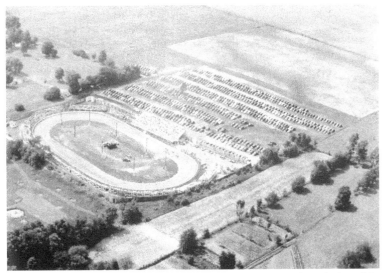

This aerial photograph of Richmond Midget Stadium was taken during the early days of the track's existence. Hundreds of cars are shown in the parking lot of the racetrack once located near US 40. After its inaugural season, the 1/5 oval dirt track was paved. Today, remnants of the popular track can be found at its original site. (Courtesy of Wayne County Historical Museum.)

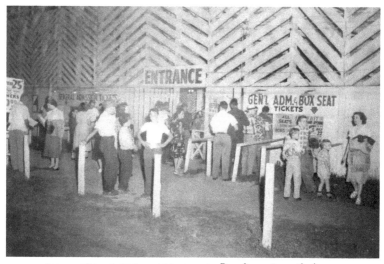

Race fans wait outside the entrance of Richmond Midget Stadium in the late 1940s. Tickets were priced at 85¢ for general admission, $1.50 for grandstand, and $1.75 for box seats. Programs featuring names of drivers and order of heats were 25¢ each. Richmond Midget Stadium opened in 1940 and closed in 1963. (Courtesy of Wayne County Historical Museum.)

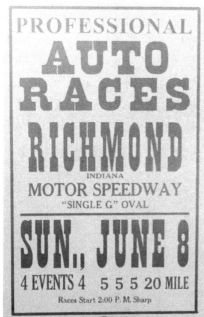

Billboards and posters served as a means to promote races at the Richmond Speedway. This early-1950s poster promoted four races on the oval track scheduled for June 8, a Sunday afternoon. (Courtesy of Wayne County Historical Museum.)

This pit pass for the Richmond Midget Stadium is on display at the Wayne County Historical Museum in downtown Richmond. A pit pass allowed drivers and mechanics access to the pit area during competition. (Courtesy of Wayne County Historical Museum.)

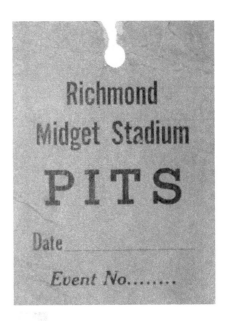

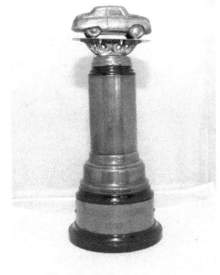

The name of the winning driver on this trophy is illegible, but the date reads 1952, and the race occurred at the Richmond Speedway. The car model on the trophy suggests that the award went to the winner of a stock car race. In the beginning, a stock car was modified from its original form in order to compete in auto racing. (Courtesy of Wayne County Historical Museum.)

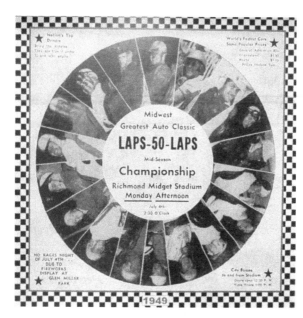

The Midwest Greatest Auto Classic was held on July 4, 1949, and featured many of the nation's top midget race drivers, including Bobby Jackson, Earl Smith, Bill Johnson, and Woody Campbell. The mid-season race was held in the afternoon due to a fireworks display scheduled that evening at Glen Miller Park. (Courtesy of Wayne County Historical Museum.)

This is an advertisement for the grand opening of the Richmond Speedway dated April 28, 1957. A field of 30 micro-midgets competed in the Sunday afternoon event. Micro-midget racing was popular in the late 1940s and early 1950s. Although the advertisement mentions a grand opening, the Richmond Speedway had been in operation at the site of the Richmond Midget Stadium since 1951. (Courtesy of Wayne County Historical Museum.)

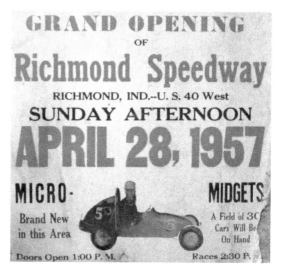

4

SUN VALLEY SPEEDWAY

Sam Skinner won the first Little 500 at Sun Valley Speedway in Anderson on May 27, 1949. The Muncie resident started the race in eighth position driving a car owned by Walt Straber. Skinner led for 234 laps of the 500-lap race, with Tom Cherry sitting on the pole position. For many years, the Little 500 was held on the eve of the Indianapolis 500 and attracted drivers and spectators from all regions of the country. (Courtesy of Anderson Speedway.)

In the image at left, Charles David "Flagman" Unger waves the checkered flag at Sun Valley Speedway, where he was flagman for more than 10 years. Unger flagged for another 20 years at Muncie racetracks and was part of a traveling thrill show in the central Indiana area. Below, race flags are displayed at the Tomlinson Cemetery grave site of Flagman Unger. The Muncie resident loved all aspects of racing—from go-karts to motorcycles and cars. Matt Unger placed these flags at his father's grave to show his love for the sport. Flagman Unger passed away in 2019 at the age of 84. (Both, courtesy of Matt Unger.)

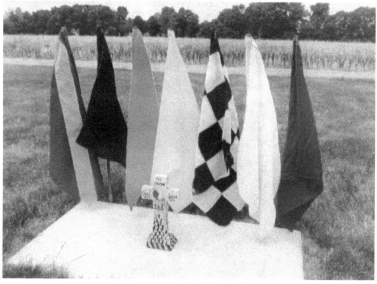

Pit passes were issued to pit crew members at Sun Valley Speedway so they had access to restricted areas. This pit pass is from the early 1950s. Many times, pit crew members had to rebuild wrecked cars on-site before sending them back onto the track. (Courtesy of Anderson Speedway.)

This unused free general admission ticket for Sun Valley Speedway was good for races scheduled for May 15 or May 22, 1954. If races were postponed, the ticket could be used at a later date. On May 29 of that year, Tom Cherry of Muncie won his third Little 500, followed by a fourth win in 1955. (Courtesy of Anderson Speedway.)

SUN VALLEY SPEEDWAY
HOME OF THE "LITTLE 500"
Sun Valley • Anderson, Indiana

This 1950s program features a photograph of the entrance of Sun Valley Speedway. In 1948, owner Joe Helpling opened the racetrack near Twenty-ninth Street and Pendleton Avenue. The Roaring Roadsters and AAA Midgets were the most popular races of the day, attracting hundreds of people to Sun Valley Speedway every Saturday night. One year after the speedway opened, Helpling came up with the idea of holding a 500-lap race for roadsters on the 1/4 track. The race would soon be known as the Little 500. (Courtesy of Anderson Public Library.)

Sun Valley Speedway was within walking distance of Guide Lamp, one of many General Motors plants located in the city. Blue-collar workers could unwind at Sun Valley Speedway, cheering on local drivers as they advanced to the winner's circle. The advertisement on the cover of this 1951 program is from the Emge Packing Company, promoting Emge's skinless franks. Though the Figure 8 was one of the more popular races at Sun Valley Speedway, attendance declined through the years. In the late 1970s, Sun Valley Speedway was renamed Anderson Speedway. (Courtesy of Edward Hewitt.)

Roadsters were a huge draw during the height of Sun Valley Speedway's popularity. This free *Sun Valley Magazine* was offered to paying customers in 1956. (Courtesy of Jeff Busby.)

Programs at Sun Valley Speedway sold for 25¢ apiece during the 1948 race season. The program included advertisements from local businesses and information on drivers competing in various races. (Courtesy of Jeff Busby.)

The official 1965 program for Sun Valley Speedway promoted the fabulous Figure 8 on its cover. The Figure 8 was embraced by local race fans as one of their favorite competitions, mainly due to the antics of the daredevil drivers. (Courtesy of Jeff Busby.)

The ninth annual Little 500 was held on July 6, 1957, complete with a fireworks show after the race. Pictured in the advertisement is 1956 Little 500 winner Bob Cleberg. The 1957 race was won by Johnny White of Warren, Michigan, who started the race on the outside of the first row. (Courtesy of Jeff Busby.)

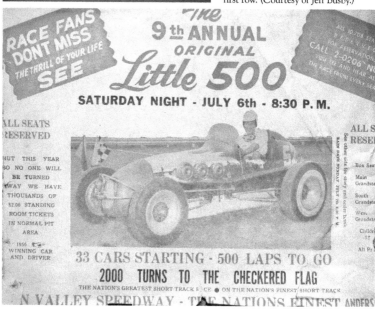

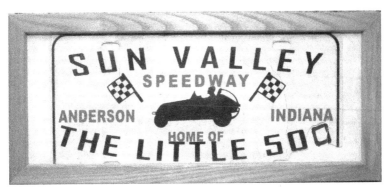

The Anderson Speedway Gift Shop sold reproductions of the Little 500 license plate. This original license plate dates back to the early 1960s. (Courtesy of Jeff Busby.)

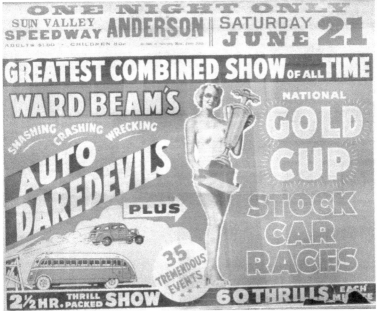

Sun Valley Speedway's "Greatest Combined Show of All Time" featured stock car races and Ward Beam's Auto Daredevils. The date of this particular event was June 21, 1952. Ward Beam is credited as being the originator of the auto thrill show. The Dive Bomb and Transcontinental Bus Jump were two of the more popular attractions performed by stunt drivers. Beam hailed from Celina, Ohio, just across the border from Jay County, Indiana. (Courtesy of Jeff Busby.)

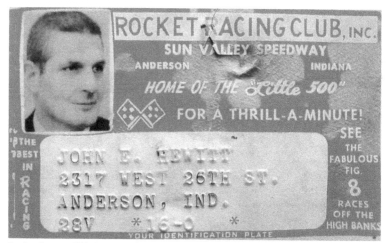

Rocket Racing Club, Inc., membership cards were issued to drivers at Sun Valley Speedway, including Anderson's own John E. Hewitt. The membership card was for drivers who competed in Figure 8 races at Sun Valley Speedway (sometimes several competitions on Saturday nights). Hewitt raced for many years at Sun Valley Speedway and is buried alongside his wife, Marilyn, at Maplewood Cemetery in Anderson. (Courtesy of Ed Hewitt.)

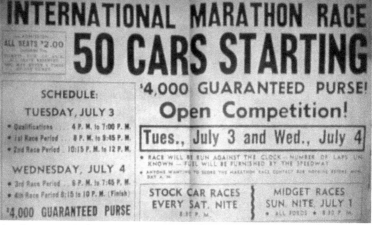

An advertisement for the International Marathon Race at Sun Valley Speedway was featured in the Anderson newspaper. The event was scheduled for July 3 and 4, 1962. The run-against-the-clock race offered a guaranteed purse of $4,000 to the winning driver. Admission to the race was $2 per ticket. (Courtesy of Anderson Speedway.)

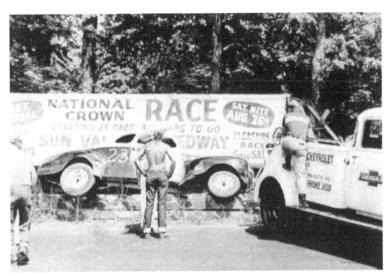

Winchester Speedway was not only the site of this wreck, it also apparently featured a billboard advertisement for Sun Valley Speedway. The first annual National Crown Race was scheduled for Saturday, August 26, 1950. Note that the telephone number on the wrecker is 26501. (Courtesy of Anderson Speedway.)

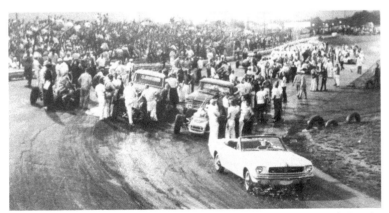

Drivers and crew members gather on the straightaway before the start of the 1964 Little 500. The newly manufactured Ford Mustang was the pace car for the race. The 1964 Little 500 was won by Dick Good of Mishawaka, Indiana. (Courtesy of Jeff Busby.)

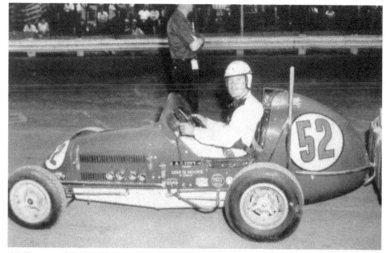

A.J. Foyt posed for this photograph at the 1961 Little 500 at Sun Valley Speedway in Anderson. Foyt went onto an illustrious career in auto racing, winning the Indianapolis 500 race four times. (Courtesy of Anderson Speedway.)

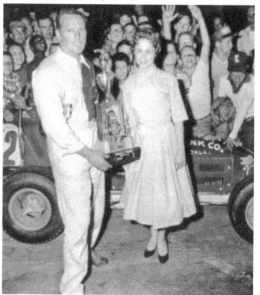

A.J. Foyt is all smiles after winning a midget race at Sun Valley Speedway in 1960. Foyt's midget car was built by John Zink, whose cars won over 100 championships, including the Indianapolis 500 in 1955 and 1956. In 1960, Foyt was the USAC national champion and the USAC Sprint Car Series champion. (Courtesy of Anderson Speedway.)

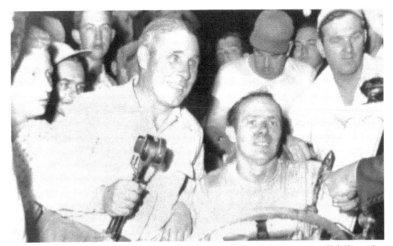

Sun Valley Speedway owner Joe Helpling (holding microphone) is interviewing Bob King after he won the 1953 Little 500. King drove car No. 99, owned by Frank Brown, to the victory lane. King hailed from Muncie and was one of two drivers to finish the 500-lap race. (Courtesy of Anderson Speedway.)

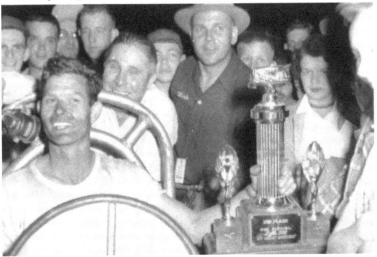

Jonnie Key of Salinas, California, is all smiles after finishing second at the 1953 Little 500 race. Key led the race from lap 300 to lap 499 before winner Bob King passed him on the final lap. This race was held on May 29, 1953. (Courtesy of Anderson Speedway.)

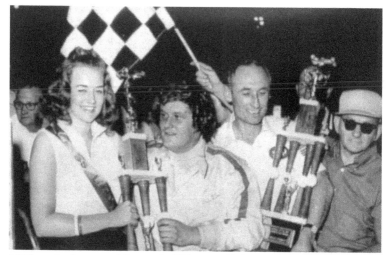

Jeff Bloom (in the center of the image) of Kalamazoo, Michigan, accepts his first-place trophy after winning the 1977 Little 500. At right is Robert Smith, who was runner-up in the race. Smith resided in Gibsonton, Florida, and started the 1977 Little 500 on the pole position. Bloom, who led the last 108 laps of the race, also won the Little 500 in 1972. (Courtesy of Anderson Speedway.)

Pete Hutchison (right) receives a trophy from Sun Valley Speedway's Butch Brooks. Hutchison lived in the city of Anderson and was employed by the Emge Packing Company as a truck driver. (Courtesy of Anderson Speedway.)

Dick Frazier Jr. poses for a photograph in his roadster sponsored by Hack's Motor Service. The Muncie resident competed in the 1970 Little 500, where he started the race in the 22nd position and placed 23rd. Frazier was forced out of the race on lap 117 due to his engine overheating. (Courtesy of Anderson Public Library.)

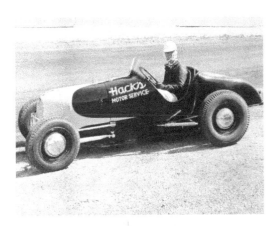

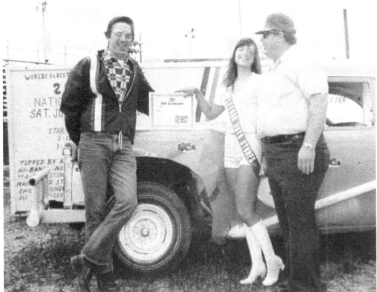

Darwin Blankenship (left) receives a gift certificate from employees of Fleenor's Auto Store after winning the 1973 National Crown Championship at Sun Valley Speedway. The New Castle resident raced stock cars for 47 years and won a total of four National Crown Championships (known as the "Longest Running Stock Car Race in the Country"). Blankenship competed in several race circuits and was recognized as one of the most talented Figure 8 drivers. Blankenship passed away on April 22, 2011, at age 69. (Courtesy of Scott Blankenship.)

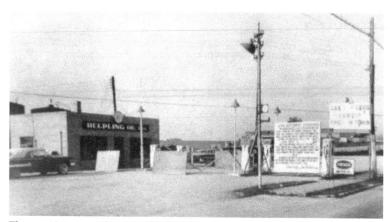

This rare 1940s image shows the Helpling Motor Company once located outside Sun Valley Speedway. Joe Helpling owned both the service station and the speedway. A sign near the station advises loyal customers that the station would be temporarily closed but would reopen soon. At the time, gasoline was 24¢ per gallon. The signature of Helpling is at the bottom of the sign, which includes a promise to serve the community "Till the Day I Die." (Courtesy of Jeff Busby.)

Billboards outside Sun Valley Speedway served as a means for advertising local businesses. One of the signs is for Schuster Brothers, a men's clothing store then located on the corner of Eighth and Main Streets in downtown Anderson; owner Jacob Schuster was the son of Russian immigrants. In the background is the Helpling Motor Company. (Courtesy of Jeff Busby.)

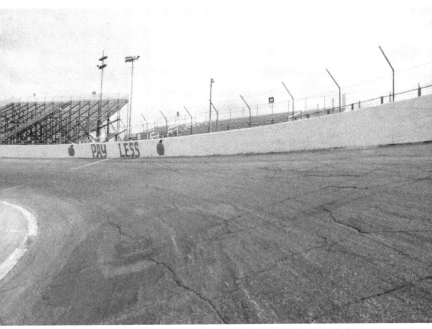

This image of turn four at Sun Valley Speedway, dubbed the "World's Fastest High-Banked Quarter-Mile Oval Track," proves that slogan correct. The quarter-mile track featured corners angled at 17 degrees, which contributed to many accidents at the speedway. At the 1968 Little 500, driver Harry Kern was involved in a four-car crash on turn two. Kern, a 42-year-old chauffeur from St. Paul, Minnesota, died less than an hour later at St. John's Hospital from injuries sustained in the accident. (Courtesy of David Humphrey.)

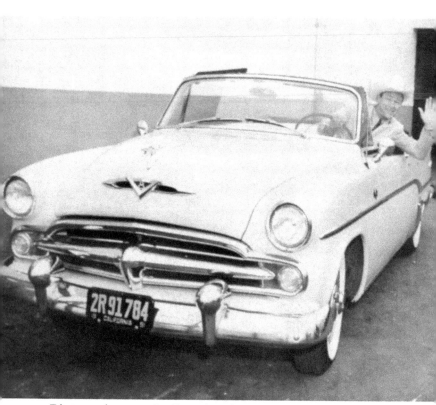

Television and movie star Roy Rogers drove the pace car at the 1954 Little 500. Here, Rogers waves to the camera while sitting in a 1954 Dodge Royal 500 V-8. During the 1950s and 1960s, several Hollywood stars drove pace cars at the Little 500, including James Garner, Clint Walker, and Vince Edwards. In 1967, Jimmy Clark attended the Little 500 the night before competing at the Indianapolis 500. The Scottish-born racing phenomenon said, "Utterly fantastic. The most amazing race I've seen." (Courtesy of Anderson Public Library.)

NOTORIOUS JUNGLE PARK

Jungle Park Speedway was founded in 1926 by Earl Padgett. The half-mile circular track was located in Parke County on the banks of Sugar Creek. The sprint car track was asphalt on the straightaway with loose gravel in the corners. Several drivers and spectators were killed at the racetrack, which became known as the "Notorious Jungle Park Speedway." The track closed and reopened multiple times, with the final race taking place in 1960. This program is from the early days of the track's existence. (Courtesy of Mark Dill.)

Jungle Park

Official Program

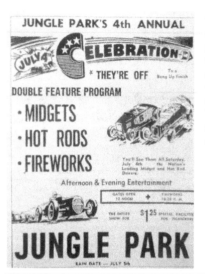

This advertisement promotes Jungle Park's 4th Annual July 4 Celebration—one of the speedway's most well-attended events of the year. Admission was $1.25 per person. In the early days of the speedway, spectators had to cross the track to get to the concession stand. Eventually, owners found this to be too dangerous and built a concession stand below the grandstand area. (Courtesy of Parke County Public Library.)

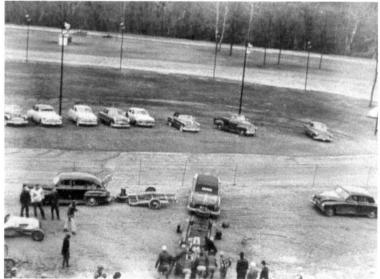

Owners and pit crew members unload race cars at Jungle Park as spectators park their vehicles in the infield. Races at Jungle Park were popular with Indiana residents as well as people in the neighboring state of Illinois. (Courtesy of Gene Crucean.)

NOTORIOUS JUNGLE PARK

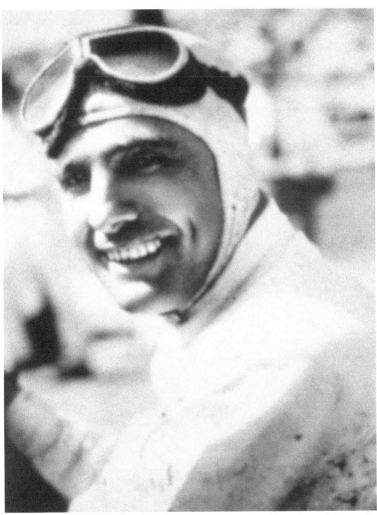

Jungle Park was the favorite racetrack of Ira Hall, who was unbeatable at the track during the 1930s. During this time, Hall became known as the "King Of Jungle Park." Hall competed in 687 races and won money at 585 contests, including a seventh-place finish at the 1932 Indianapolis 500. After retiring from racing, the native of Martinsville, Indiana, moved to Vigo County and served two separate terms as sheriff. Hall is a member of the National Sprint Car Hall of Fame. (Courtesy of Vigo County Historical Society.)

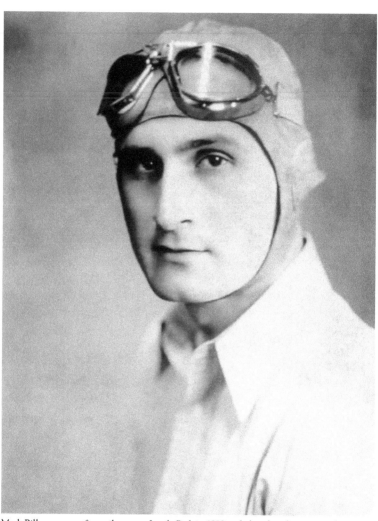

Mark Billman won a five-mile race at Jungle Park in 1929 and placed in the money other times. But the hard-luck driver from Indianapolis might be best remembered for surviving a horrific crash at Jungle Park a year earlier, when he sustained a broken hip that left him nearly crippled. Despite his debilitating injury, Billman continued to race on the Midwest circuit, eventually qualifying for the 1933 Indianapolis 500. The 27-year-old driver finished 79 laps before crashing in the second turn; Billman died at an Indianapolis hospital as a result of his injuries. (Courtesy of Mark Dill.)

NOTORIOUS JUNGLE PARK

Joie Ray was born in Louisville, Kentucky, on September 29, 1923, and competed in his first auto race in 1947. Ray became a well-known driver in the Midwest and regularly raced in Indiana. Unlike many of his fellow drivers, Ray enjoyed racing at Jungle Park Speedway. Driving a six-cylinder Ford or four-port Riley, Ray could control his car on the hot, oil-slicked track while others drivers lost control. (Courtesy of Dave Argabright.)

Chick Smith, of Louisville, Kentucky, won the first race held at Jungle Park after the end of World War II. Smith drove to victory on September 23, 1945. He was featured in an advertisement promoting races at Jungle Park that appeared in the *Indianapolis Star* on September 26, 1947. Smith was very supportive of fellow Louisville-born driver Joie Ray. Smith once demanded that Ray be allowed to stay in a whites-only motel in Terre Haute, which demonstrates the strong camaraderie between the two men. (Courtesy of Gene Crucean.)

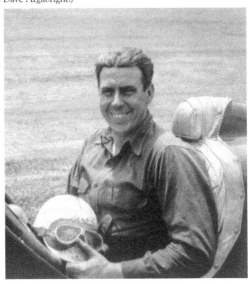

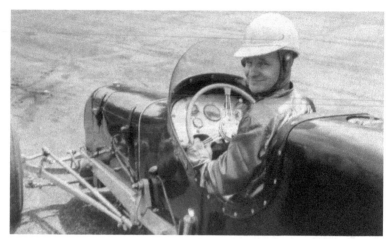

Elbert "Pappy" Booker posed for this photograph at Jungle Park in the early 1940s. Records indicate that Booker placed second in the first heat at Jungle Park on Mother's Day in 1942. Later that day, Booker placed third in the feature race. In 1946, Booker was a AAA Midwest champion, but he died in a crash one year later while racing in Dayton, Ohio. (Courtesy of Gene Crucean.)

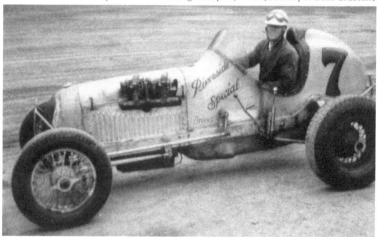

Edward "Bus" Woolbert competed in midget races throughout central Indiana, including at Jungle Park. Woolbert won the feature race at Jungle Park on July 26, 1942, and the final race held at the track in front of 3,000 fans. Woolbert was killed on August 11, 1946, while racing at Funk's Speedway (now known as Winchester Speedway) in Winchester, Indiana. At the time of the crash, the 30-year-old driver was leading the race. (Courtesy of Gene Crucean.)

NOTORIOUS JUNGLE PARK

Ray Duckworth raced sprint cars throughout the Midwest from the late 1940s until 1969. One of the tracks where Duckworth competed was the notorious Jungle Park. In fact, the Anderson, Indiana, native was the last known promoter of Jungle Park. The World War II and Korean War veteran died in 2009 at the age of 86. (Courtesy of Gene Crucean.)

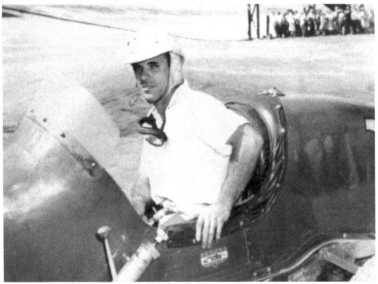

George Robson is pictured at Jungle Park Speedway during the 1941 season. Robson began dirt track racing in the mid-1930s, frequently competing in Indiana. Robson won the 1946 Indianapolis 500 but was killed later that year in an accident at Lakewood Speedway in Atlanta, Georgia. (Courtesy of Gene Crucean.)

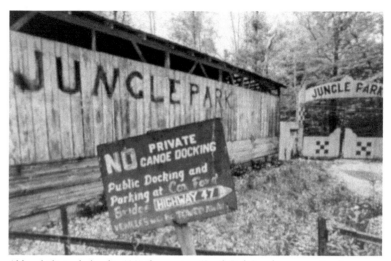

Although the track closed in 1960, the remains of Jungle Park Speedway attract fans from across the country. The entrance to Jungle Park, with its hand-painted signs, looks the same as it did when the track was open. Every September, during the Rumble in the Jungle, classic cars are shown and race enthusiasts walk the grounds of the abandoned track. (Courtesy of Indiana Landmarks.)

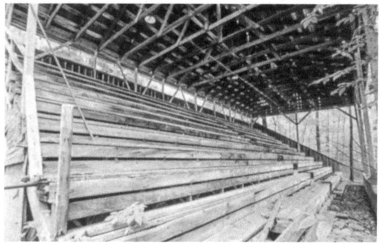

Some sections of the bleachers where spectators gathered to watch races at Jungle Park Speedway still stand. Jungle Park is one of the most legendary and popular closed racetracks in Indiana. (Courtesy of Indiana Landmarks.)

6

On the Shores of
Winona Lake

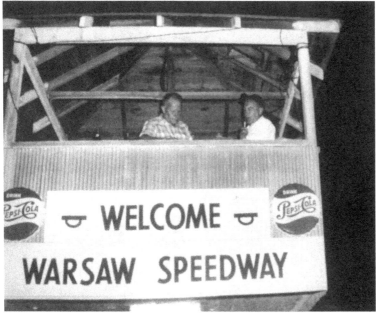

Hoot Gibson (left) and Milo Clase stand in the announcer's tower at Warsaw Speedway on April 29, 1961. Clase was the public-address announcer at Warsaw Speedway and broadcast Saturday night races on radio station WRSW. Warsaw Speedway opened in 1949. Located on the north shores of Winona Lake in Warsaw, Indiana, the quarter-mile track was considered one of the most scenic of its kind in the United States. It hosted its last race in the summer of 1990. (Photograph by Wayne Bryant.)

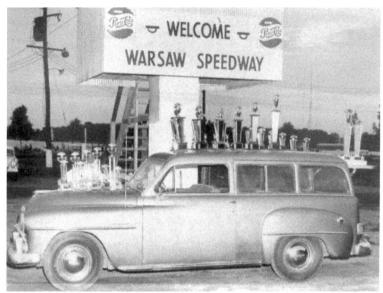

This assortment of trophies was on display prior to the 1959 Championship Lap Race held at Warsaw Speedway. Drivers from Kokomo, Columbia City, South Bend, Logansport, and Noblesville competed at Warsaw Speedway during the 1959 season, which ran from May through October that year. Below, Milo Clase (left) and Hoot Gibson are pictured with the trophies. Clase and Gibson were popular and well-known figures at the track located in Kosciusko County. (Both, photograph by Wayne Bryant.)

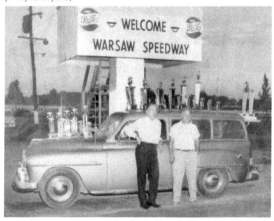

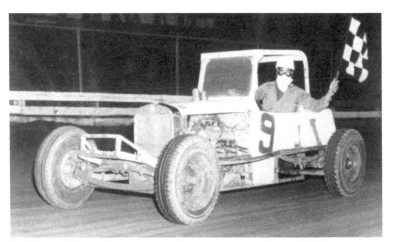

Bud Stillwell of Kokomo, Indiana, was one of the winning drivers on October 3, 1959 during the last race of the stock car season. Over 1,000 spectators braved threatening weather to attend the event that included an end-over-end crash by Warsaw's own Jim Lozier. (Photograph by Wayne Bryant.)

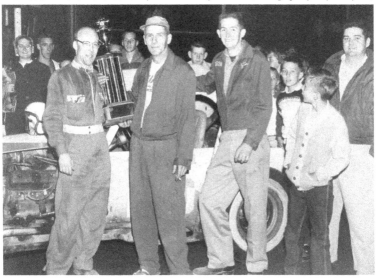

Bob Ziegler of South Bend, Indiana, won the feature race and stock feature at Warsaw Speedway on September 12, 1959. A total of 64 drivers qualified for this Saturday night's races. In this picture, Ziegler (at far left) is being presented with one of his trophies. (Photograph by Wayne Bryant.)

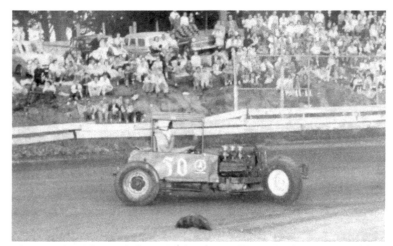

July 4, 1960, featured one of the largest crowds ever to jam Warsaw Speedway. Spectators did not walk away disappointed after witnessing top-notch races—and many accidents. Boats on Winona Lake and cars parked in every available spot were filled with race fans who watched the dazzling fireworks show that concluded the day's events. (Photograph by Wayne Bryant.)

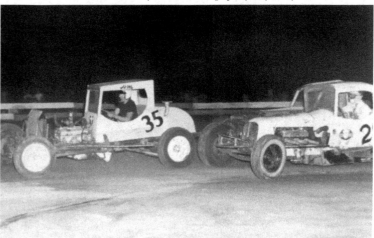

Jim Elliot passes a competitor during a Labor Day race in 1959. The hometown hero won many races at Warsaw Speedway and was the points leader in the modified division in 1969. Elliot was also the sprint season points champion from 1970 to 1972. He was killed in a motorcycle crash on March 6, 1973, at the age of 40. (Photograph by Wayne Bryant.)

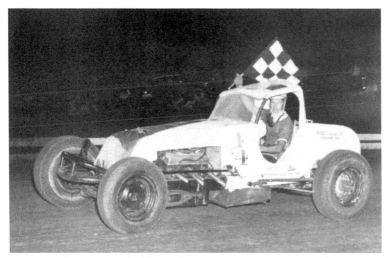

Beezer Humphries won the third heat in his race on September 5, 1959. Archie Holle and Bob Staley placed second and third in the heat, respectively. Humphries hailed from Kokomo. (Photograph by Wayne Bryant.)

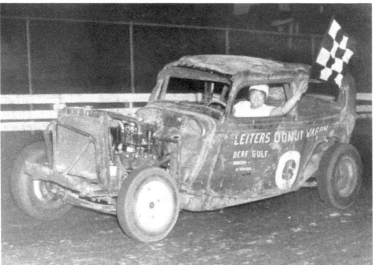

Max Lambert waves the checkered flag after a win on September 9, 1957. In 1959, Lambert was season points stock champion. Lambert was a Warsaw resident. (Photograph by Wayne Bryant.)

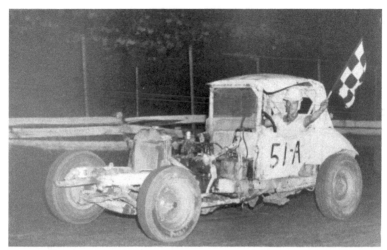

Luther Holloway was victorious in the second heat of races held on September 7, 1959. The Columbia City resident competed many times at Warsaw Speedway during the mid- to late 1950s. (Photograph by Wayne Bryant.)

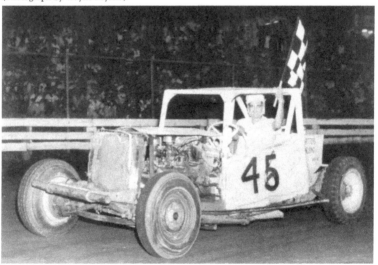

Jim Rebeck of Gary, Indiana, won the first heat at Warsaw Speedway on August 8, 1959. An estimated 5,000 people were on hand to watch more than 60 drivers compete for the checkered flag. (Photograph by Wayne Bryant.)

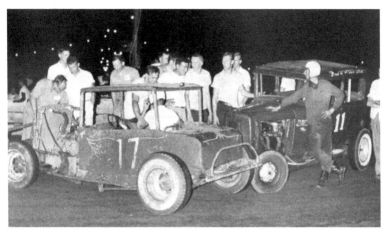

Drivers involved in a crash at Warsaw Speedway are shown waiting for a wrecker to tow disabled cars away. Wrecks at Warsaw Speedway were common and often resulted in serious injuries or even death. On August 9, 1958, mechanic Walter Schroeder was running from the infield to the pit area and fell on the track. Unable to gain his footing, Schroeder was run over by several cars and died at the scene. (Photograph by Wayne Bryant.)

Thrills and spills were a part of racing at Warsaw Speedway on August 1, 1959. Beezer Humphries rolled his car several times, then went over the wall. Luckily, he walked away from the crash. Drivers Joe Scott, Pealy Heckaman, and Don Schroeder also wrecked that evening but were not seriously injured. (Photograph by Wayne Bryant.)

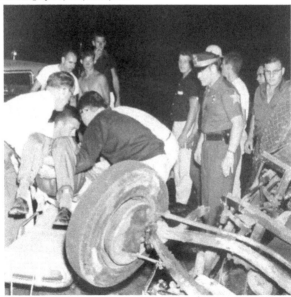

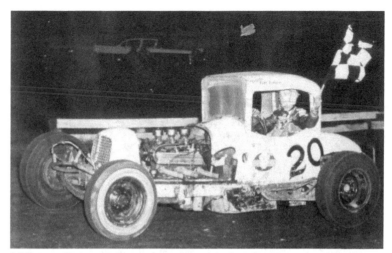

Bill Fortune of Kokomo, Indiana, raced stock cars throughout the 1959 season and placed first in a heat on September 9. This was the penultimate race during the summer of 1959. (Photograph by Wayne Bryant.)

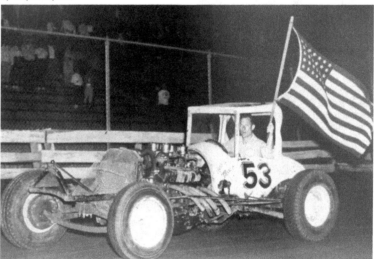

Archie Holle recorded the fastest lap at the track on October 3, 1959. The Warsaw native was also a heat-winner in that summer's final event. Holle had won other heats in the stock car division the previous spring. (Photograph by Wayne Bryant.)

ON THE SHORES OF WINONA LAKE

Winning drivers pose for a group photograph at the 1959 Hot Rod Banquet held at the American Legion in Columbia City. Seated at far right in the front row is Paul Hazen, who raced for years at Warsaw Speedway. The Columbia City man went onto become a successful sprint car owner, with a career spanning over 50 years. In 2019, Hazen was honored with a historical marker at Kokomo Speedway. (Photograph by Wayne Bryant.)

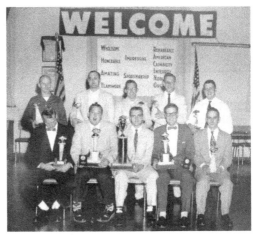

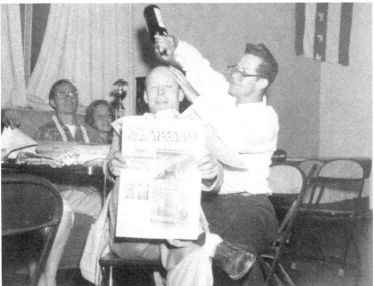

Guests at the 1959 Hot Rod Banquet clowned around for the camera. The gentleman at right is "pouring" Canadian Club whiskey onto the seated victim, who obviously has a bald head. The Stewart Brothers Orchestra provided music, and dancing continued until 1:30 in the morning. A banner at the banquet read, "From Columbus to Kokomo. To Kalamazoo. The Best in Racing Right Here For You." (Photograph by Wayne Bryant.)

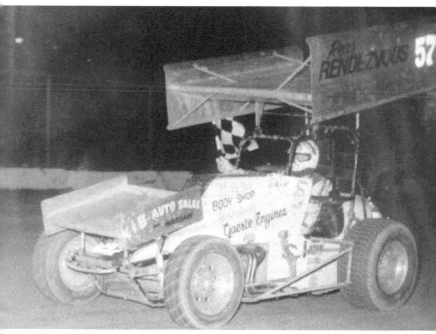

On June 19, 1982, Tony Elliot won the sprint fast heat and sprint feature and placed second in the sprint dash. The hometown hero went onto win many races at Warsaw Speedway before embarking on a successful career on the sprint car circuit. (Photograph by Wayne Bryant.)

LEGENDARY DRIVERS

Ray Harroun won the inaugural Indianapolis 500 on May 30, 1911. Nicknamed the "Little Professor," Harroun drove the No. 32 Marmon "Wasp" to victory with an average speed of 74.602 mph. Harroun's earnings for winning the first Indianapolis 500 totaled $14,250. Though Marmon was born in Spartansburg, Pennsylvania, he later lived in Anderson, Indiana, where he died on January 19, 1968, at the age of 89. Harroun is buried at Anderson Memorial Park Cemetery. (Courtesy of Anderson Public Library.)

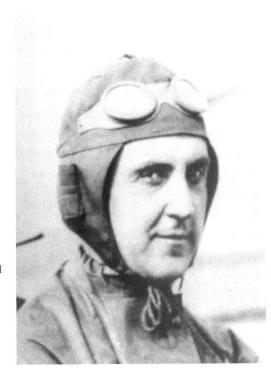

I·M·S·

INDIANAPOLIS MOTOR SPEEDWAY

Good for One Grandstand Seat

No. 4052

SERIES H

The first race held at the Indianapolis Motor Speedway took place on August 19, 1909. During the race, riding mechanic Claude Kellum was killed when driver Charles Merz wrecked on lap 70. Kellum, age 32, was living in Indianapolis at the time of his death and was buried in his hometown of Kokomo, Indiana. This is a general admission ticket for the race. (Courtesy of Mark Dill.)

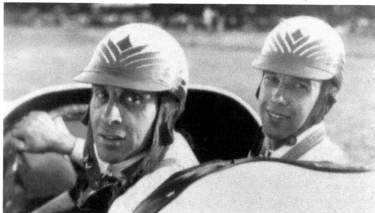

Joseph Kennelly (right) served as riding mechanic for Johnny Seymour at the 1936 Indianapolis 500. After his short stint as a riding mechanic, Kennelly worked at Allison Engineering near Speedway, Indiana, through the 1980s. Kennelly lived in Indianapolis and died on September 16, 2011, at the age of 97. He was the oldest living Indianapolis 500 riding mechanic. (Courtesy of Marion County Public Library.)

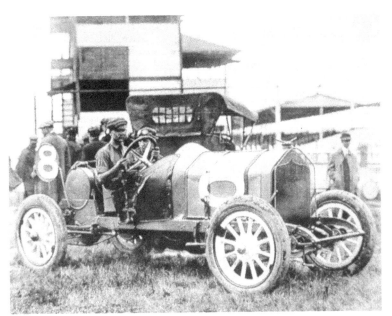

Joe Dawson was the first Indiana native to win the Indianapolis 500. Dawson hailed from the town of Odon and won the Indianapolis 500 in 1912 at age 22. Dawson placed 5th in the 500-mile race in 1911 and 25th in 1914, after which he retired from auto racing. He returned to the Indianapolis Motor Speedway in 1928 to drive the pace car. Dawson was a protege of Ray Harroun and worked as an engineer and in management for the Marmon firm. In later years, Dawson was a supervisor for the American Automobile Association. He died in 1948 at the age of 57. (Courtesy of Odon Winkelpleck Public Library.)

Joe Dawson won the 1912 Indianapolis 500 with an average speed of 78.719 mph. An estimated 75,000 people attended the race. (Photograph by David Humphrey.)

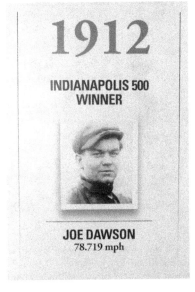

1912

INDIANAPOLIS 500 WINNER

JOE DAWSON
78.719 mph

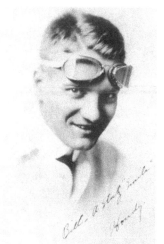

Howdy Wilcox of Crawfordsville, Indiana, won the 1919 Indianapolis 500. Wilcox competed in the first 11 Indy 500s, and had five top-five finishes and one pole position. At the 1919 Indianapolis 500, Wilcox started in second position and led the last 98 laps of the race. He died in a car crash at Altoona Speedway in Tyrone, Pennsylvania. Wilcox was 34 years old when he died and is buried at Crown Hill Cemetery in Indianapolis. (Courtesy of Brian Wilcox.)

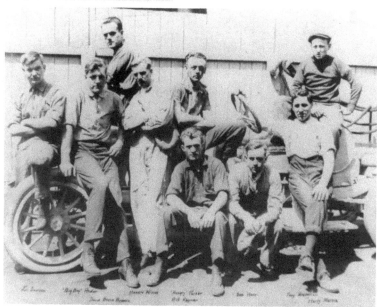

Howdy Wilcox (fourth from left) poses with associates in this early-1900s photograph. Pictured are, from left to right, Joe Dawson, "Big Boy" Rader, David Brown, Wilcox, "Hungry" Farber, Bill Kepner, Don Herr, Harry Scudellam, and Harry Martin. (Courtesy of Brian Wilcox.)

LEGENDARY DRIVERS

Hoosier pride gets hypo from Wilcox

By WAYNE FUSON
The Indianapolis News

500 History — Part II

Howdy Wilcox

Eddie Rickenbacker

This article on Howdy Wilcox appeared in the May 9, 1987, edition of the *Indianapolis News*. The journalist writes that Wilcox, his riding mechanic (Leo Banks), and car owners Carl Fisher and James Allison were all Hoosiers, and they won the Indianapolis 500 on a Hoosier track. According to sources, this was the first time "Back Home Again in Indiana" was performed at the Indianapolis 500, in honor of Wilcox. (Courtesy of Brian Wilcox.)

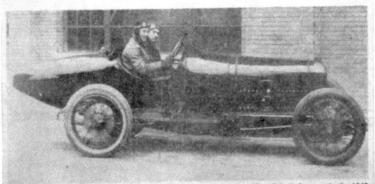

500-Mile Entry List

French 'Ghost' Entered in 500-Mile Classic

Lindley F. Bothwell of Woodland Hills, Cal., has entered a 1919 French-built Peugeot in the 1949 500-mile race at the Indianapolis Motor Speedway May 30th. Shown above is a Peugeot with Howdy Wilcox at the wheel after he had won the 1919 classic at an average speed of 87.95 mph. Bothwell has entered and will drive the car to compare its performance with the streamlined versions of today.

Howdy Wilcox sits behind the steering wheel of a 1919 French-built Peugeot with passenger Lindley Bothwell of Woodland Hills, California. Bothwell entered this Peugeot—the same type of car Wilcox drove to victory in 1919—in the 1949 Indianapolis 500, but he failed to qualify for the race. (Courtesy of Brian Wilcox.)

INDIANA'S LOST SPEEDWAYS AND LEGENDARY DRIVERS 67

1919

INDIANAPOLIS 500 WINNER

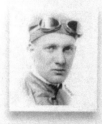

HOWDY WILCOX
88.050 mph

Howdy Wilcox claimed victory at the 1919 Indianapolis 500 with an average speed of 88.050 mph. A crowd of roughly 120,000 people attended the event. (Photograph by David Humphrey.)

This trophy, presented to Howdy Wilcox for winning the 1919 Indianapolis 500, is on display at the Indianapolis Motor Speedway Museum. The first Borg-Warner trophy was presented to Louis Meyer after he captured the 1936 Indianapolis 500. (Photograph by David Humphrey.)

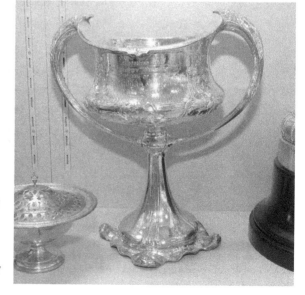

LEGENDARY DRIVERS

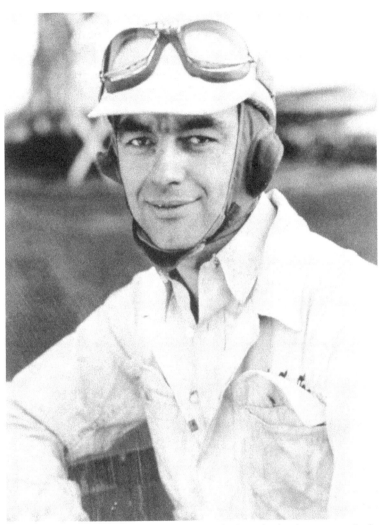

L.L. "Slim" Corum raced seven times at the Indianapolis 500 and is listed as cowinner for the 1924 event. Driver Joe Boyer relieved Corum on lap 109 and is also credited with winning the 1924 Indianapolis 500. Corum, from Jonesville, Indiana, is often referred to as the "Forgotten '500' Winner." He died at age 50 on March 7, 1949, and is buried in Indianapolis. (Courtesy of Bartholomew County Historical Society.)

George Souders of Lafayette, Indiana, drove a Duesenburg Special to the victory lane at the 1927 Indianapolis 500. Souders is one of nine rookies who won the Indianapolis 500 on his first attempt. However, the first Indy 500 Rookie of the Year Award was not presented until 1952. Souders started the race in 22nd position and led the last 51 laps to win the championship. The following year, Souders finished third, then he all but vanished from the racing scene. He died at age 75 on July 28, 1976, and is buried at Battle Creek Cemetery in Tippecanoe County, Indiana, near his hometown. (Courtesy of Tippecanoe County Historical Association.)

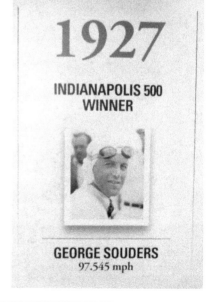

With an average speed of 97.545 mph, George Souders placed first at the 1927 Indianapolis 500. The pace car that year was driven by Willard "Big Boy" Rader. (Photograph by David Humphrey.)

Louis Schneider was born and raised in Indianapolis and won the 1931 Indianapolis 500. Prior to becoming a race car driver, Schneider worked as a motorcycle policeman and competed in motorcycle races. The year Schneider won the Indy 500, he was also the AAA driving champion. Schneider was involved in a car crash during a 1938 midget race in San Diego, California, and died at the age of 40 on September 22, 1942; he is interred at Crown Hill Cemetery. (Photograph by David Humphrey.)

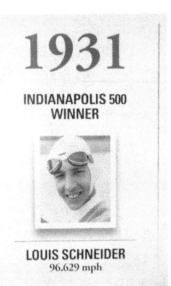

1931

INDIANAPOLIS 500
WINNER

LOUIS SCHNEIDER
96.629 mph

1934

INDIANAPOLIS 500
WINNER

BILL CUMMINGS
104.863 mph

"Wild" Bill Cummings competed in the Indianapolis 500 nine times, winning the event in 1934. The Indianapolis native grew up just four miles from the Indianapolis Motor Speedway and earned the nickname "Wild" from his father, William. Cummings was popular with race fans and peers alike. On February 6, 1939, Cummings lost control of his car while driving on wet pavement and landed in a creek. He died two days later at age 32 and is buried in his hometown of Indianapolis. (Photograph by David Humphrey.)

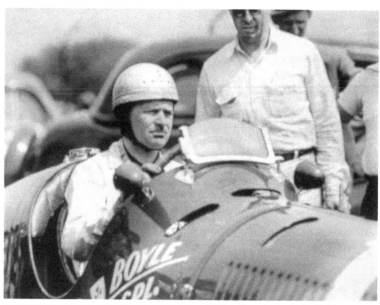

Wilbur Shaw sits in the Boyle Maserati 8CTF that he drove to victory in the 1939 and 1940 Indianapolis 500 races. Shaw was the first driver to win the prize in two consecutive years. (Courtesy of Indiana Historical Society.)

1937

INDIANAPOLIS 500 WINNER

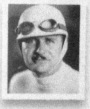

WILBUR SHAW
113.580 mph

Wilbur Shaw was the first three-time winner of the Indianapolis 500, taking home first-place honors in 1937, 1939, and 1940. From 1935 to 1940, Shaw not only won three Indy 500 races but finished in second place twice, in 1935 and 1938, and in seventh place in 1936. Shaw raced 13 times in the Indianapolis 500; his last appearance was in 1941. Born in Shelbyville, Indiana, on October 31, 1902, Shaw died in an airplane crash near Decatur, Indiana, on October 30, 1954. (Photograph by David Humphrey.)

LEGENDARY DRIVERS

In 1928, Indianapolis-born Charles "Dutch" Baumann won 43 of 52 races in which he competed. Baumann drove a car built and owned by Arthur Chevrolet. During his racing career, Baumann competed at many Indiana tracks, including Jungle Park, Kokomo, Winchester, and Logansport. Baumann was killed on August 16, 1930, while racing at Kankakee, Illinois. The 32-year-old was laid to rest at Holy Cross and St. Joseph Cemetery in Indianapolis. In 2013, Baumann was inducted into the National Sprint Car Hall of Fame. (Courtesy of Parke County Historical Society.)

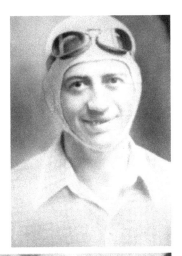

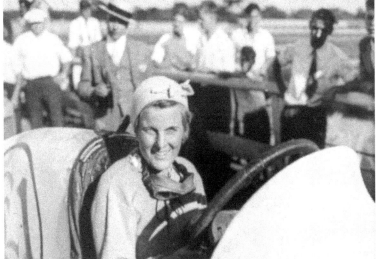

Elfrieda Mais might be the "best race car driver you never heard of," according to Indianapolis writer Will Higgins. Born in Indianapolis and raised on the west side of the city, Mais showed interest in auto racing at an early age but was never allowed to compete because she was a woman. Mais went on to a career as a wing-walker and, later, stunt driver. On September 27, 1934, Mais, then 42 years old, was killed while performing a stunt at the Alabama State Fair. She is buried at Crown Hill Cemetery in Indianapolis. (Courtesy of Indiana Historical Society.)

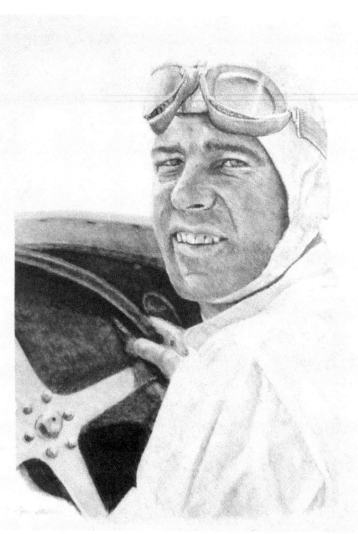

Bob Carey was born on September 24, 1904, in Anderson, Indiana, to Clifford and Nannie Carey. He lived on the east side of the city with his parents and three siblings. After working for General Motors in his hometown, Carey embarked on a successful but short-lived career in auto racing. This drawing was created by award-winning artist Sam Mudd, nephew of Bob Carey. (Courtesy of Sam Mudd.)

LEGENDARY DRIVERS

Bob Carey and his wife, Lennie, are shown doing yard work outside their family home. The two married in 1923 and had one child, Bob. Lennie was born in Shirley, Indiana, and passed away at age 97 in Gas City, Indiana. (Courtesy of Sam Mudd.)

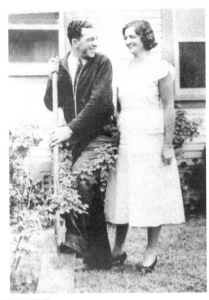

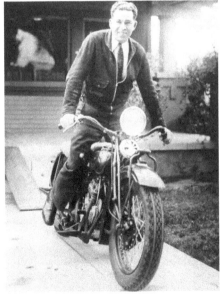

Though he never raced motorcycles, Bob Carey enjoyed wheels of speed. According to his nephew Sam Mudd, Carey once wrecked his motorcycle while crossing railroad tracks, which resulted in a broken back. (Courtesy of Sam Mudd.)

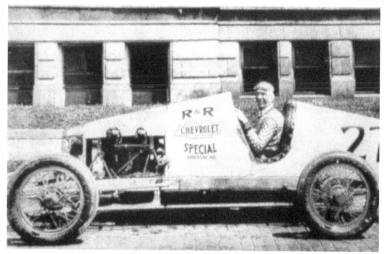

Bob Carey sits in a car sponsored by R&R Manufacturing Co. of Anderson. Owner Robert Roof was chief engineer for the company and worked in the auto racing industry throughout the United States. (Courtesy of Sam Mudd.)

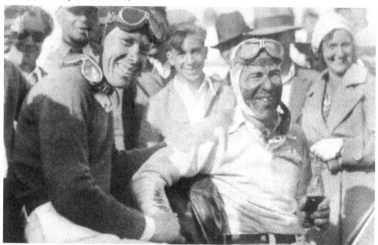

Bob Carey (right) celebrates after winning one of many races in his stellar career. Carey was the AAA national champion in 1932 and finished fourth that year at the Indianapolis 500. His riding mechanic during the race was Lawson "Useless" Harris. In 2005, Carey was inducted into the National Sprint Car Hall of Fame. (Courtesy of Sam Mudd.)

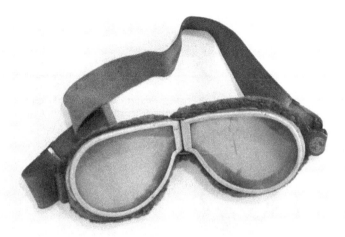

The protective goggles worn by Bob Carey during his racing career consisted of glass and a leather strap. They were damaged by rocks and debris flying from cars in Carey's path. Drivers from this era often had their teeth chipped or knocked out from flying objects. (Courtesy of Sam Mudd.)

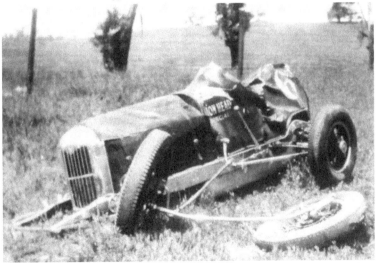

On April 16, 1933, Bob Carey was killed during qualifying rounds at the Legion Ascot Speedway in Los Angeles. It is believed that the accident was caused by a stuck throttle. Carey, who won the first race he ever entered in 1921, was on the verge of greatness in the auto racing world. He is buried at Maplewood Cemetery in his hometown of Anderson. (Courtesy of Sam Mudd.)

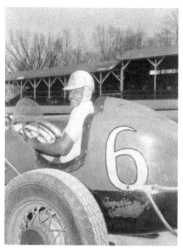

Charles "Dynamite" Stewart was a student of fellow Hoosier and racing legend Charlie Wiggins. Stewart raced at the Gold and Glory Sweepstakes, held at the Indiana State Fairgrounds, during the 1930s, driving a Schofield Special in 1936. Stewart was given the nickname Dynamite because he consistently blew up engines. (Courtesy of Gene Crucean.)

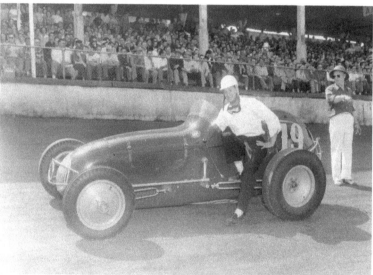

Larry "Crash" Crockett earned his nickname due to several accidents early in his career. But the Columbia City, Indiana, native learned to maneuver an automobile, winning Rookie of the Year at the 1954 Indianapolis 500. The following spring, Crockett was killed during a sprint car race in Langhorne, Pennsylvania. Crockett, 28, was survived by his wife, Mary Jane, and was laid to rest at Garland Brook Cemetery in Columbus, Indiana. (Courtesy of Gene Crucean.)

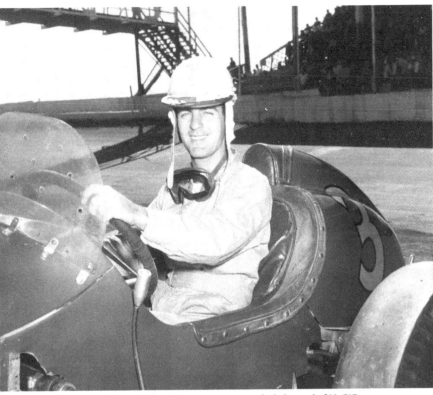

Pat O'Connor was one of the most beloved drivers to compete at the Indianapolis 500. O'Connor, of North Vernon, Indiana, competed in 43 championship races in his career and had two wins. In addition, he earned two pole positions at the Indy 500. O'Connor began racing roadsters in 1948 while working as a car salesman. He finished eighth at the Indianapolis 500 in 1955 and 1957 and vowed to quit auto racing if he ever won the Indy 500. But O'Connor's fate was sealed when he was killed during the opening lap of the 1958 Indy 500. In 1995, he was inducted into the National Sprint Car Hall of Fame. This picture of O'Connor was taken at Winchester Speedway in 1953. (Courtesy of Gene Crucean.)

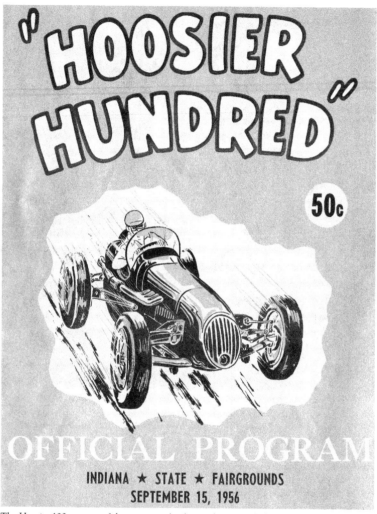

"HOOSIER HUNDRED"

50c

OFFICIAL PROGRAM

INDIANA ★ STATE ★ FAIRGROUNDS
SEPTEMBER 15, 1956

The Hoosier 100 was one of the more popular dirt track races in Indiana. For many years, it was held at the Indiana State Fairgrounds and included some of the top drivers in the country—Parnelli Jones, Mario Andretti, Rodger Ward, and Al Unser Sr., to name a few. This program is from the 1956 Hoosier 100 won by Jimmy Bryan. For his first-place victory, Bryan received $7,750. (Courtesy of Indiana State Archives.)

National Sprint Car Hall of Famer Bob Kinser won over 400 features during his 40-year racing career. Kinser began racing jalopies at the Bloomington Speedway in his hometown of Bloomington, Indiana. During the 1970s, 1980s, and 1990s, Kinser competed in sprint car races throughout the Midwest and belonged to several sprint car organizations. Bob, the Kinser family patriarch, is the father of Steve and Randy Kinser, who are successful and talented race car drivers in their own rights. (Courtesy of Anderson Speedway.)

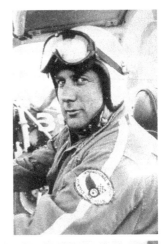

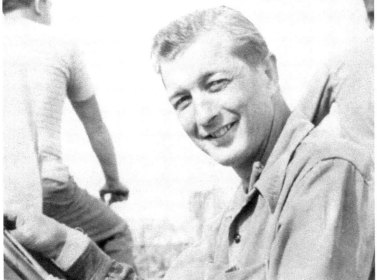

After serving his country in World War II, Tom Cherry focused on auto racing. In the late 1940s, he opened Tom Cherry Automotive in his hometown of Muncie, Indiana. Cherry graduated from roadsters to midgets in the early 1950s, setting records and winning races along the way, including four wins at the Little 500 in Anderson. Cherry is a member of the Little 500 Hall of Fame and the National Sprint Car Hall of Fame. (Courtesy of Alexandria Historical Society.)

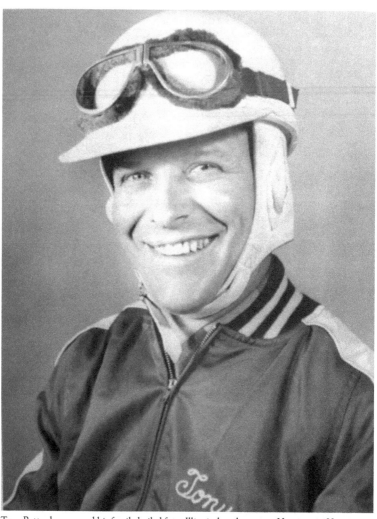

Tony Bettenhausen and his family hailed from Illinois, but they are as Hoosier as a Hoosier can get. From 1946 through 1959, Bettenhausen was victorious in 21 national championship races, winning the national title in 1951 and 1958. He participated in 14 Indianapolis 500 races, with his best finish at second in 1955 (he shared the honors with Paul Russo). Bettenhausen was killed at age 44 at the Indianapolis Motor Speedway in 1961 while testing a car for fellow driver Russo. He is buried at Crown Hill Cemetery. (Courtesy of Merle Bettenhausen.)

LEGENDARY DRIVERS

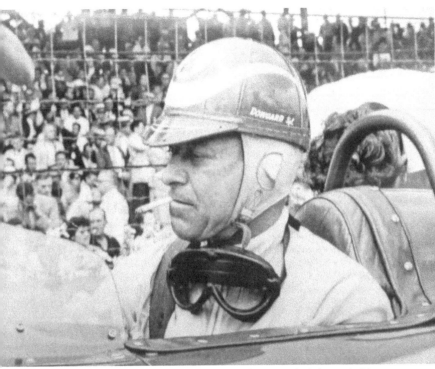

Tony Bettenhausen puffs on a cigarette while waiting in the pits at the Indianapolis Motor Speedway. Early in his career, Bettenhausen was known as the "Tinley Park Express" in honor of his hometown. He was inducted into the Indianapolis Motor Speedway Hall of Fame in 1968. (Courtesy of Gene Crucean.)

Gary Bettenhausen takes a break during practice at the Indianapolis Motor Speedway. Between 1968 and 1993, Bettenhausen competed in 21 Indianapolis 500 races. His best finish was third place in 1980. Bettenhausen won four USAC National Driving Championships and has been inducted into the National Spring Car Hall of Fame, National Midget Auto Racing Hall of Fame, and United States Auto Club Hall of Fame. On March 16, 2014, the Monrovia, Indiana, resident passed away at home at the age of 72. (Courtesy of Merle Bettenhausen.)

Gary "Schmuck" Bettenhausen (right) watches car owner and chief mechanic Willie "Cork" Davis work on his Thermo King sprint car at Winchester Speedway in 1972. Davis served as crew chief for Bettenhausen when he placed third at the 1980 Indianapolis 500. Davis has been inducted into the National Sprint Car Hall of Fame. (Courtesy of Merle Bettenhausen.)

LEGENDARY DRIVERS

Merle Bettenhausen posed for this publicity photograph during the early days of his racing career. He is one of Tony Bettenhausen's three sons—the other two are Gary and Tony Jr. As a young man, Merle raced midgets, sprint cars, and champion cars, with five USAC midget wins to his credit. In 1972, Bettenhausen passed his mandatory rookie driver's test at the Indianapolis Motor Speedway but made no attempt to qualify for the 500-mile race that year. (Courtesy of Merle Bettenhausen.)

During the summer of 1966, Merle Bettenhausen kept a record while racing at Lawton Speedway. Bettenhausen won five of the 17 races he competed in, taking home his share of $155. (Courtesy of Merle Bettenhausen.)

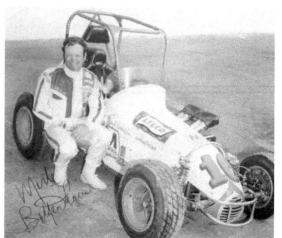

On July 16, 1972, Merle Bettenhausen was involved in a fiery crash at the Michigan International Speedway that resulted in him losing his right arm. With a prosthetic arm, Bettenhausen made his comeback in 1973. He won his first race as a one-armed competitor at Johnson City, Tennessee, on August 31, 1973. (Courtesy of Merle Bettenhausen.)

Merle Bettenhausen (left)—pictured with his wife, Leslie (center), and Dr. Smart of University of Michigan Medical Hospital—is shown receiving the 1972 Hoosier Auto Racing Fans' Sportsmanship Award. Dr. Smart supervised Bettenhausen's surgery and rehabilitation. Bettenhausen currently resides in Indianapolis. (Courtesy of Merle Bettenhausen.)

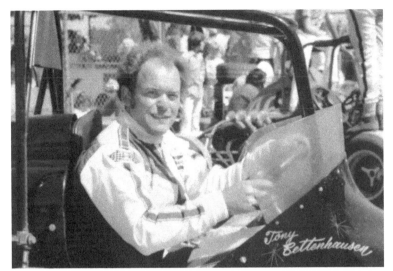

Tony Bettenhausen Jr., the youngest son in the Bettenhausen family, raced 11 times in the Indianapolis 500. His best finish was seventh place in 1981, his rookie year. In 1969, he began racing stock cars, but he switched to Indy cars in 1979. Tony Jr. founded Bettenhausen Motorsports in 1986 and served as driver and owner. (Courtesy of Merle Bettenhausen.)

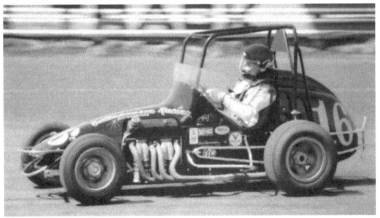

Tony Bettenhausen Jr. races the Bettenhausen midget car at Terre Haute in 1976. He was named USAC Rookie of the Year in 1979. Tragically, Tony Jr. and his wife, Shirley, were killed in a plane crash on February 15, 2000. Two other people also died in the crash. Tony Jr., the "Gentleman Driver," is buried at Crown Hill Cemetery in Indianapolis. (Courtesy of Merle Bettenhausen.)

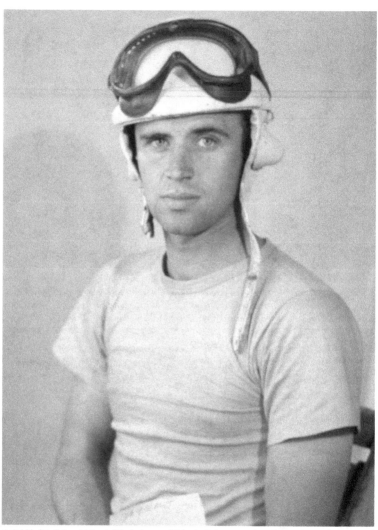

A field behind the old Rock Wool plant in Wabash, Indiana, is where Jimmy Daywalt first raced cars. The Wabash native soon joined the Central States Racing Association and began racing competitively in Fort Wayne, Terre Haute, and Logansport. In 1953, Daywalt was named Rookie of the Year after finishing in sixth place at the Indianapolis 500. He died of cancer at age 41 and is buried at Crown Hill Cemetery. (Courtesy of Wabash Historical Society.)

LEGENDARY DRIVERS

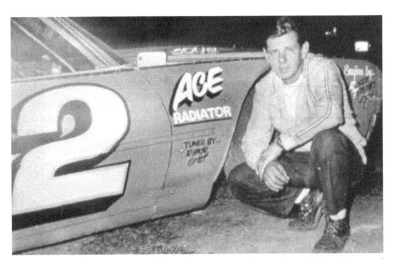

Art Terlosky raced for several years in the Fort Wayne area, mainly in stock car divisions. He restored classic cars and owned A.T. Automotive for over 30 years. Terlosky is a member of the Avilla and Baerfield Speedways Hall of Fame in Allen County. (Courtesy of Allen County Public Library.)

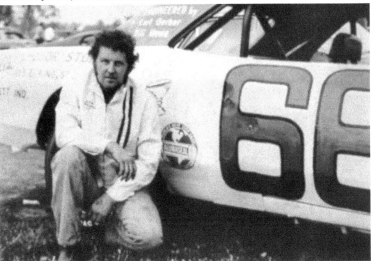

Don Pinkerton poses for a photograph at Fort Wayne's Avilla Speedway in 1977. The Garrett, Indiana, native was known for his patience with young drivers and serving as a mentor at Fort Wayne racetracks. (Courtesy of Allen County Public Library.)

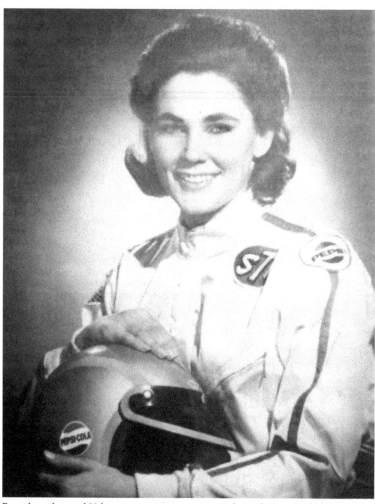

From the early to mid-20th century, auto racing was primarily a male-dominated sport. However, that did not keep Indiana-born Mary Anne Butters off the racetrack. Butters competed in races throughout North America, with several appearances at Indianapolis Raceway Park (now Lucas Oil Raceway). Butters was nicknamed "The Tiger" by her husband, Tom, who was also involved in auto racing. The racing suit worn by Butters in this official portrait was compliments of Andy Granatelli. (Courtesy of Mary Anne Butters.)

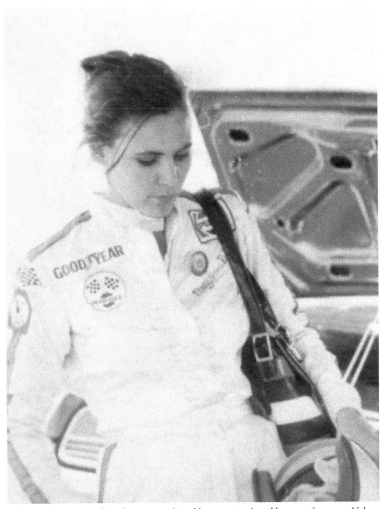

Mary Ann Butters stands in the pit area after a blown engine forced her out of a race at Nelson Hedges, Ohio. (Courtesy of Mary Anne Butters.)

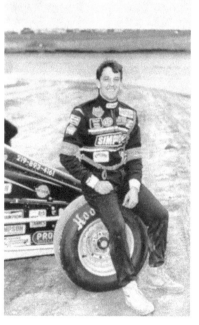

Jeff Gordon was born in California, but the Gordon family relocated to Pittsboro, Indiana, while Jeff was in his teens. This allowed the young Gordon to compete in open-wheel racing throughout the Midwest. Gordon went on to be successful in stock car racing; he was named the Winston Cup Rookie of the Year in 1993 and won the inaugural Brickyard 400 the following year. Gordon won his fifth Brickyard 400 in 2014, one year before he retired from auto racing. (Courtesy of Gene Crucean.)

Tony Stewart was born and raised in Columbus, Indiana, and still lives in his hometown. Stewart is the first and only driver to win championships in Indy cars, stock cars, sprint and Silver Crown cars, and open-wheel midgets. Stewart also has three NASCAR Cup Series Championships and was named Rookie of the Year in USAC (1991), Indianapolis 500 (1996), and the NASCAR Cup Series (1999). Stewart retired from auto racing in 2016. (Courtesy of Gene Crucean.)

LEGENDARY DRIVERS

Like his father Tim, Tony Elliot began racing in his hometown of Warsaw, Indiana. Early in Tony's career, he won five track championships in Kokomo and two at Gas City. In 1998, he won his first USAC National Sprint Car crown, winning a repeat championship in 2000. On October 2, 2015, Elliot was one of four people killed in a plane crash after it took off from Warsaw Municipal Airport; he was 54 years old. Tony Elliot was inducted into the National Sprint Car Hall of Fame in 2017. (Courtesy of Anderson Speedway.)

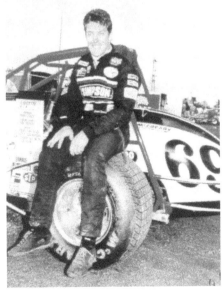

Robbie Stanley was the USAC Sprint Car national champion in 1991, 1992, and 1993. Many race enthusiasts believed that the Brownsburg, Indiana, native was on the verge of winning a fourth USAC National Sprint Car Championship in 1994. Sadly, Stanley was killed at age 26 on May 24, 1994, while racing at Winchester Speedway. The once-rising star was inducted into the National Sprint Car Hall of Fame (2005) and the Hoosier Auto Racing Fans Hall of Fame (1994). (Courtesy of Gene Crucean.)

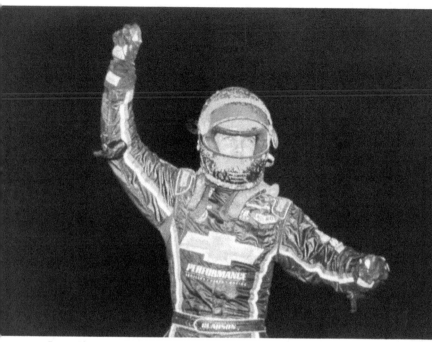

Bryan Clauson raises his fist after claiming victory in a midget car race. During his career, Clauson won two USAC National Sprint Car Championships and two USAC National Midget Car Championships. The Noblesville, Indiana, resident competed in three Indianapolis 500 races, finishing 23rd in the 100th running of the prestigious event in 2016. Clauson was a hero to fans on and off the track, where he raised money for autism awareness in racing events. On August 7, 2016, Clauson died from injuries sustained in a crash at the Belleville Midget Nationals in Kansas—he was 27 years old. (Courtesy of Clauson Racing.)

8

BEHIND THE SCENES

The founding fathers of the Last Row Society pose for a photograph at an early bash. Pictured here are, from left to right, Gerry Lafollette, David Mannweiler, Art Harris, and Robin Miller. The Last Row Society raises funds for the Indianapolis Press Club Foundation, which awards journalism scholarships. The last row qualifiers for the Indianapolis 500 receive checks for 31¢, 32¢, and 33¢. The first Last Row Party was held in 1972. (Courtesy of Robin Miller.)

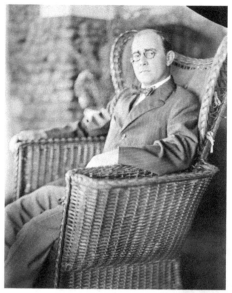

Carl Fisher served as president of the Indianapolis Motor Speedway from 1909 to 1923. Fisher has been credited as being the originator of the idea of the Indianapolis 500 race and using a passenger vehicle as a pace car. Fisher drove the pace car at the Indianapolis 500 on five different occasions, including the inaugural 1911 race. Widely known for his promotional stunts, Fisher once pushed a Stoddard-Dayton automobile off the roof of his Indianapolis car dealership, then drove it away on four flat tires. Fisher was born in Greensburg, Indiana, on January 12, 1874, and died in Florida at age 65. He is buried at Crown Hill Cemetery. (Courtesy of Indiana Historical Society.)

James Allison took over ownership of the Indianapolis Motor Speedway in 1923 and continued as head of operations until 1927, before he sold the speedway to Eddie Rickenbacker. Allison founded the Indianapolis Motor Speedway in 1909 with partners Carl Fisher, Arthur Newby, and Frank Wheeler and went on to establish the Indianapolis Speedway Team Company on West Sixteenth Street, south of the track. The company changed its name to Allison Experimental Co. and, later, Allison Engineering Co. Allison was born in Michigan, but his family moved to Indianapolis when he was young. Indianapolis served as Allison's home until his death in 1928 at the age of 55. (Courtesy of Indiana Historical Society.)

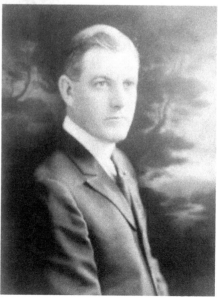

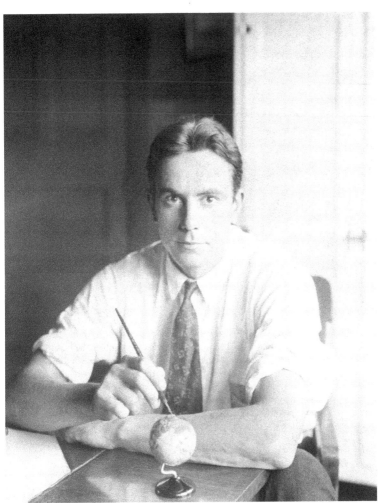

Anton "Tony" Hulman Jr. purchased the Indianapolis Motor Speedway in 1945 and prevented the grounds from becoming a housing complex. The speedway suffered greatly during the years of World War II, but Hulman brought new life to the track with vast improvements and renovation. In 1956, Hulman established the Indianapolis Motor Speedway Museum and is widely known for his command, "Gentlemen, start your engines." Hulman died in 1977 at the age of 76 and is buried in his hometown of Terre Haute, Indiana. (Courtesy of Indiana Historical Society.)

Sid Collins (wearing a bow tie) and Wilbur Shaw (wearing glasses) spoke to WIBC radio audiences about Pyroll automotive chemicals. This event took place one week prior to the 1954 Indianapolis 500. In 1952, Collins began his career as the radio voice for the Indianapolis 500 and continued in that role until 1976. He died on May 2, 1977. When this photograph was taken, Shaw was president and general manager of the Indianapolis Motor Speedway. Shaw was killed in a plane crash five months later near Decatur, Indiana. Both of these Indiana natives are now in the Indianapolis Motor Speedway Hall of Fame. (Courtesy of Indiana Historical Society.)

The front cover of this Indianapolis Motor Speedway booklet features images of Tony Hulman and Wilbur Shaw. After Hulman purchased the Indianapolis Motor Speedway in 1945, he served as chairman of the board and named Shaw both president and general manager. (Courtesy of Brian Wilcox.)

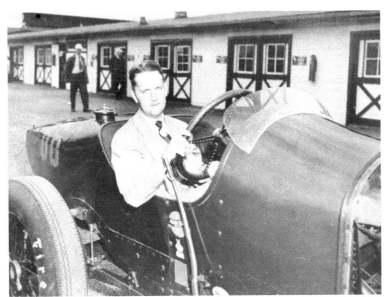

Howdy Wilcox Jr. sits in a race car once owned by his father, Howdy Wilcox, who won the 1919 Indianapolis 500. In 1951, Wilcox Jr. founded the Little 500, a bicycle race held each year in Bloomington, Indiana, while serving as executive director of the Indiana University Student Foundation. His intent was to raise money for student scholarships and emulate the Indianapolis 500 race. Dubbed the "World's Greatest College Weekend," the Little 500 was the subject of the movie *Breaking Away* (1979), which was nominated for five Academy Awards. At the time of his death in 2002, Howdy Wilcox Jr. lived in Noblesville. (Courtesy of Brian Wilcox.)

Mechanics and pit crew members wait alongside cars in Gasoline Alley before proceeding to the track. There is no date attached to this photograph, but all the cars in the image are front engine racers. According to records, the original Gasoline Alley was razed in 1985. (Courtesy of Indiana Historical Society.)

INDIANA'S LOST SPEEDWAYS AND LEGENDARY DRIVERS

These fans are entering the main gate of the Indianapolis Motor Speedway (IMS) prior to the 1955 race. The entrance is decorated with the IMS logo as well as a checkered design. (Courtesy of Indiana Historical Society.)

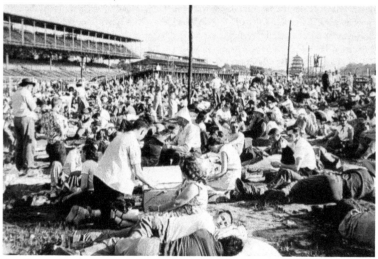

Race fans are shown passing the time as they wait for the start of the Indianapolis 500 sometime in the 1950s. Some fans are taking naps, while others chat with family and friends near turn one of the track. (Courtesy of Indiana Historical Society.)

BEHIND THE SCENES

On display in the Indianapolis Motor Speedway Museum is this piece of equipment used for every 500-mile race from the early 1950s through 1977. The operator of this device sat behind the broadcast booth and was in constant communication with track announcers. When the director issued a hand signal, the operator alerted the next announcer, flipping the appropriate switch that put them on air. (Photograph by David Humphrey.)

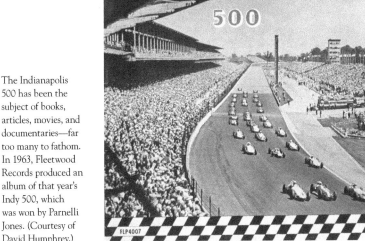

The Indianapolis 500 has been the subject of books, articles, movies, and documentaries—far too many to fathom. In 1963, Fleetwood Records produced an album of that year's Indy 500, which was won by Parnelli Jones. (Courtesy of David Humphrey.)

Wayne Bryant, a longtime race photographer, hailed from Rensselaer, Indiana. He was inducted into the South Bend Speedway Hall of Fame in 2006 and into the Warsaw Speedway Hall of Fame in 2020. Bryant photographed racing in central and northern Indiana from 1958 to 1982. (Courtesy of Warsaw Speedway.)

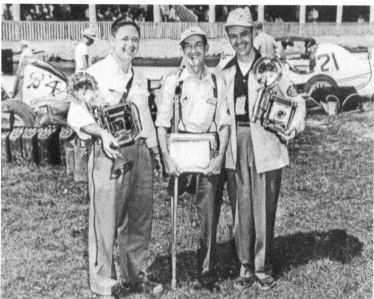

Bud Williams (left), Sparky Mace (center), and John Hyland pose for a photograph at Winchester Speedway in 1950. Williams and Hyland were popular race photographers in their day, and Mace was a flamboyant reporter of the sport. Mace stayed active long after his right leg had to be amputated; he went by the nickname "One Legged Sparky." Upon his retirement, Mace moved to the Tampa Bay area, where his love of auto racing continued. (Courtesy of Parke County Library.)

Gene Crucean is not only a collector of auto racing photographs but one of the most respected photographers in the field. Born and raised in Hammond, Indiana, Crucean fell in love with auto racing at an early age and began to photograph sprint car races, which paved his way to the Indianapolis 500. While he was a student at Indiana University, Crucean met fellow Hoosier photographer John Mahoney, and the two embarked on successful careers as photographers. In 2016, Gene Crucean was inducted into the National Sprint Car Hall of Fame. (Courtesy of National Sprint Car Hall of Fame.)

Photographers John Mahoney, Jack Kromer (center), and Gene Crucean (right) have spent decades capturing racing with their cameras. They have photographed some of the greatest names in auto racing, including Tony Bettenhausen, Rodger Ward, Dan Gurney, and Mario Andretti. In 2005, Mahoney was inducted into the National Sprint Car Hall of Fame. Kromer has also received many awards throughout his career. (Courtesy of National Sprint Car Hall of Fame.)

Lou Laroche of Wheel Horse (left) and Tom Butters (right) talk with auto racing legend Sir Jackie Stewart during the filming of a Wheel Horse commercial in Florida in 1980. In the commercial, Stewart drove a Wheel Horse tractor out of a Brinks trunk while talking about the good value of the vehicle. Butters hails from Indiana and raced in his early years. He went on to a successful career as an artist, painting some of the legendary drivers of the sport. (Courtesy of Tom Butters.)

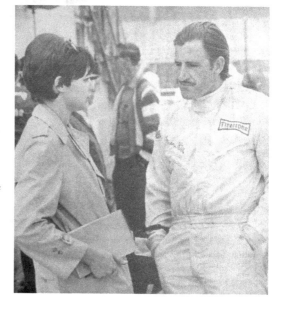

When she was not competing on the racetrack, Mary Anne Butters worked as a reporter for the *Indianapolis Star*. Here, the award-winning journalist is interviewing Graham Hill at the Indianapolis Motor Speedway in 1967. Hill won the Indianapolis 500 the previous year as a rookie. (Courtesy of Mary Anne Butters.)

Dr. Wallace Gordon Diehl is shown playing the bagpipes at the Indianapolis Motor Speedway. Dr. Diehl founded the Gordon Pipers in 1962 with fellow Highlanders Bill Simpson, John Hudgins, and Bill Cochran. One year later, the Gordon Pipers first appeared at the Indianapolis 500 in what has now become a long-standing tradition of the race. (Courtesy of Indianapolis 500 Gordon Pipers.)

Dr. Wallace Gordon Diehl (left) and Bill Cochran (right) give Scottish-born driver Jim Clark a lesson on the Great Highland bagpipe at the 1965 Indianapolis 500. (Courtesy of Indianapolis 500 Gordon Pipers.)

Dr. Wallace Gordon Diehl (standing at the podium) presented the Rookie of the Year Award to Jim Clark (behind Diehl's left shoulder) at the 1963 Indianapolis 500 Victory Banquet. Clark finished second that year behind winner Parnelli Jones. (Courtesy of Indianapolis 500 Gordon Pipers.)

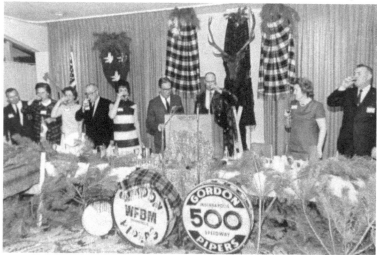

Indianapolis Motor Speedway president Tony Hulman (just left of the podium; wearing glasses) shares a toast at the 1963 Tartan Ball. In the foreground, the logos of the Gordon Pipers are featured on the band's bass drums. (Courtesy of Indianapolis 500 Gordon Pipers.)

In this 1964 photograph, Indianapolis businessman Tom McShane (left) accepts his Gordon Pipers honorary membership from Dr. Wallace Gordon Diehl (center) and Tony Hulman. (Courtesy of Indianapolis 500 Gordon Pipers.)

Dr. Wallace Gordon Diehl, wearing a checkered flag shirt, enjoys a beverage with Hugh Scotty Grant at a Gordon Pipers party the night before the 1964 Indianapolis 500. (Courtesy of Indianapolis 500 Gordon Pipers.)

Jim Nabors was one of the most beloved figures in the history of the Indianapolis 500. Between 1972 and 2014, Nabors sang "Back Home Again in Indiana" a total of 36 times during prerace festivities. Though Nabors was born in Alabama and lived most of his adult life in Hawaii, he was considered a true Hoosier by Indianapolis 500 race fans. Nabors died in 2017 at the age of 87. (Courtesy of *Indianapolis Star*.)

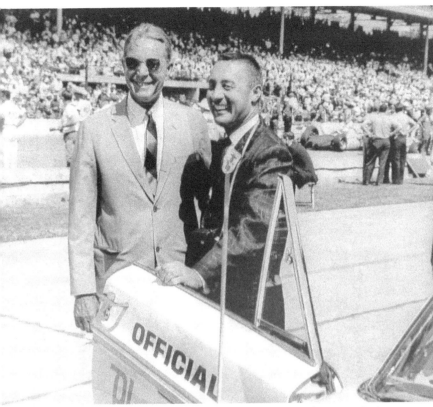

Tony Hulman (left) and Gus Grissom stand beside a Plymouth Sport Fury, the pace car for the 1965 Indianapolis 500. During prerace ceremonies, Grissom sat on the back of the pace car as it circled the speedway. Grissom, who was from Mitchell, Indiana, was one of NASA's original seven *Mercury* astronauts and the second American to fly in space. In 1966, Grissom, fellow astronaut Gordon Cooper, and driver Jim Rathmann bought a rear-engine Offenhauser and entered it into the Indianapolis 500. (Courtesy of *Indianapolis Star.*)

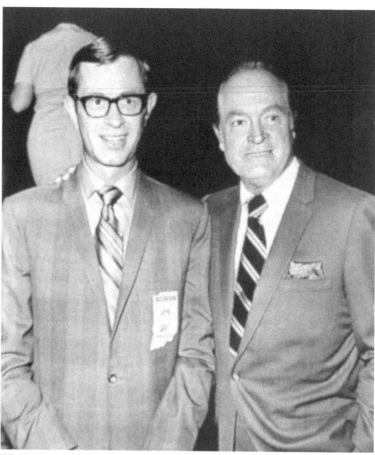

While working at WFBM radio and television in Indianapolis, Howdy Bell (left) took time to emcee *The Bob Hope Show* at the 1969 Indiana State Fair; he is pictured here with Hope. Bell, born and raised in Indianapolis, joined Sid Collins on the Indy 500 Radio Network in 1962. Bell is a member of the Indiana Broadcast Pioneers Hall of Fame and was honored by the Indiana Racing Memorial Association with a historical marker on March 7, 2020. (Courtesy of Indiana State Archives.)

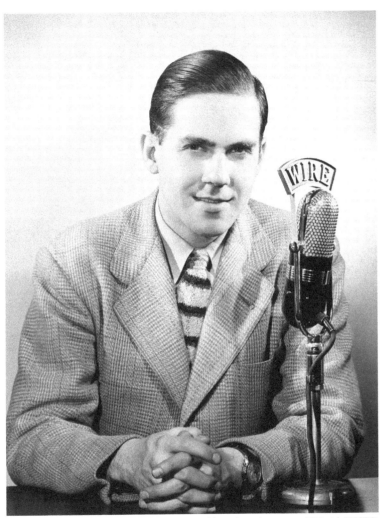

Tom Carnegie was born in Norwalk, Connecticut, and began his radio career in 1942 with WOWO, located in Fort Wayne. In 1946, Tony Hulman hired Carnegie, and that began Carnegie's 61-year tenure as the announcer at the Indianapolis Motor Speedway. Known for his signature phrases "He's on it!" and "It's a new track record!", Carnegie called his last race in 2006. Carnegie was inducted into the Indianapolis Motor Speedway Hall of Fame in 1996. He died in Zionsville on February 11, 2011, at the age of 91. (Courtesy of Indiana Historical Society.)

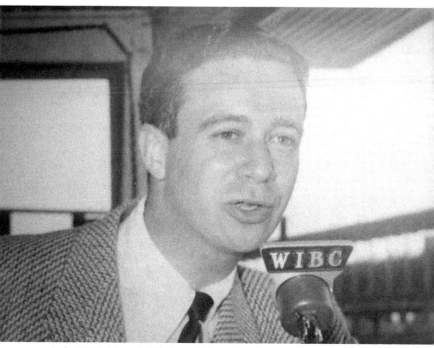

At the 1964 Indianapolis 500, drivers Eddie Sachs and Dave MacDonald were involved in a fiery second-lap crash that cost them their lives. Sid Collins was good friends with Sachs and gave the driver an impromptu eulogy after learning of his death. Collins later received over 30,000 letters from race fans asking for a copy of his touching words. His opening statement stated, "You heard the announcement from the public address system. There's not a sound. Men are taking off their hats. People are weeping. There are over 300,000 fans here not moving. Disbelieving." (Photograph by David Humphrey.)

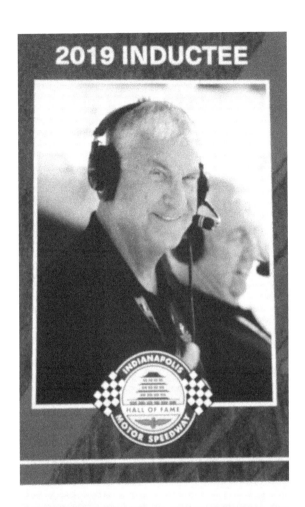

BOB JENKINS

From 1990 to 1998, Indiana native Bob Jenkins served as chief announcer of the Indianapolis 500 for the Indianapolis Motor Speedway Radio Network. The Indiana University graduate anchored NASCAR races on ESPN for over 20 years, including the first seven Brickyard 400s. Though Jenkins has retired from television work, he remains active with public address work at the Indianapolis Motor Speedway. (Photograph by David Humphrey.)

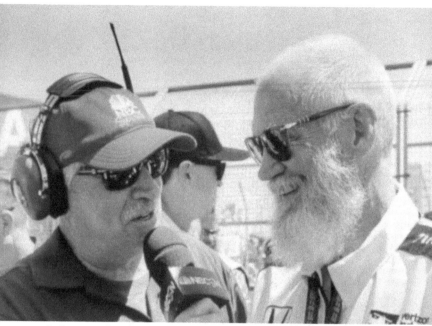

In this picture from the 2010s, Hoosier icons Robin Miller (left) and David Letterman talk auto racing at the Indianapolis Motor Speedway. Miller, a graduate of Southport High School in Indianapolis, spent 33 years as a writer for the *Indianapolis Star*. He went on to write for *ESPN*, *Car and Driver*, and *Speed* magazines and currently is the senior writer for *Racer* magazine. During the 1970s, Miller drove in the USAC midget series. Letterman graduated from Broad Ripple High School in Indianapolis before furthering his education at Ball State University. From there, he went on to an illustrious career as a host on late-night television, winning several Emmy Awards. Letterman is a member of Rahal Letterman Lanigan Racing, which has earned two Indy 500 wins. (Courtesy of Indiana Racing Memorial Association.)

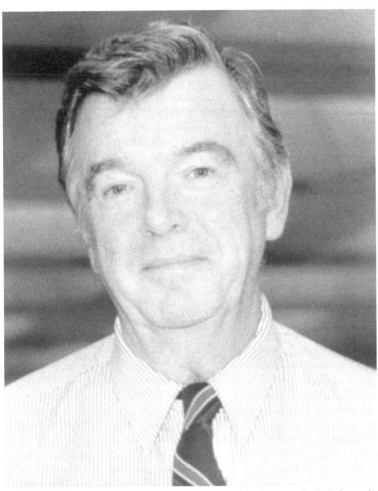

As a teenager growing up in England, Donald Davidson developed a passion for the Indianapolis 500, knowing which driver led what lap in any given year. Davidson arrived at the Indianapolis Motor Speedway in 1964, and one year later, he became a member of the Indianapolis Motor Speedway Radio Network. In 1998, Davidson joined the Indianapolis Motor Speedway Foundation as its track historian. Throughout his career, Davidson has not only amazed fans with his precise memory but has written many articles, columns, and books on the Indianapolis 500. Davidson resides in Indianapolis and was inducted into the Indianapolis Motor Speedway Hall of Fame in 2010. (Courtesy of the *Paper* of Wabash County.)

Standing at far right in the Indianapolis Motor Speedway Radio Network booth is Paul Page. Statistician John DeCamp (seated at left), producer Jack Morrow (center), and driver expert Freddie Agabashian (standing behind Morrow) also appear in this photograph taken at the 1977 Indianapolis 500. (Courtesy of Paul Page.)

Paul Page is pictured here when he was working as a pit reporter for Sid Collins in 1974. A.J. Foyt sat on the pole position that year, with the pace car being driven by 1960 Indy 500 winner Jim Rathmann. Johnny Rutherford led 122 laps of the race before crossing the finish line in first place. (Courtesy of Paul Page.)

BEHIND THE SCENES

Paul Page (right) is shown interviewing Jim Clark at the Indianapolis Motor Speedway in 1964. At age 15, Page attended his first Indy 500 and immediately knew that he wanted to become involved with the race. Page was a play-by-play commentator for the Indy 500 for 27 years on the Indianapolis Motor Speedway Radio Network and on television. Born in Evansville and now residing in Indianapolis, Page earned Emmy Awards for his coverage of the 1989 and 1990 Indianapolis 500 races. (Courtesy of Paul Page.)

Paul Page (left) is pictured with Derek Daly in 1986. Irish-born auto racer Daly competed in the Indianapolis 500 six times during the 1980s but is better known as a Formula One driver. Daly now resides in Carmel, Indiana, and is the father of race driver Conor Daly. (Courtesy of Paul Page.)

The Indiana State Archives, located in Indianapolis, houses many items from the Indiana State Fairgrounds, including those from the Hoosier 100. This ticket is from the Fourth Annual Hoosier 100, which took place at the fairgrounds on September 4, 1956. The winner of the race was Jimmy Bryan, who earned $7,750 for his first-place finish. (Courtesy of Indiana State Archives.)

In 1991, Anderson resident Tim Trueblood volunteered his services during the month of May at the Delco Remy garage. Trueblood performed a variety of tasks on Gasoline Alley and had the opportunity to meet many drivers who competed in the Indianapolis 500 that year. This garage pass was issued to Trueblood and fellow volunteers. (Courtesy of Tim Trueblood.)

BEHIND THE SCENES

Mary Hulman (far left, wearing white) sits near the track stands with friends at the 1948 Indianapolis 500. Born Mary Fendrich in Evansville, Indiana, she married Tony Hulman in 1926, later settling in Terre Haute. When Tony died in 1977, Mary became chairman of the Indianapolis Motor Speedway. The following year, Mary delivered the command Tony had made famous—"Gentlemen, start your engines!"—prior to the race. (Courtesy of IUPUI Library.)

Driver Lee Wallard shakes hands and talks to Mary Hulman at the Indianapolis Motor Speedway in 1952. Wallard won the 1951 Indianapolis 500 at the age of 40, earning him the nickname "Cinderella Man." Hulman played an active role at the annual Indianapolis 500 and was popular with drivers and fans. She died in 1998 at the age of 93. (Courtesy of IUPUI Library.)

Jane Watts Fisher is shown in downtown Indianapolis signing copies of her book *Fabulous Hoosier: A Story of American Achievement.* The subject of the book was Indianapolis 500 businessman Carl Fisher, to whom Jane was once married. This photograph was taken on March 5, 1947. (Courtesy of Indiana Historical Society.)

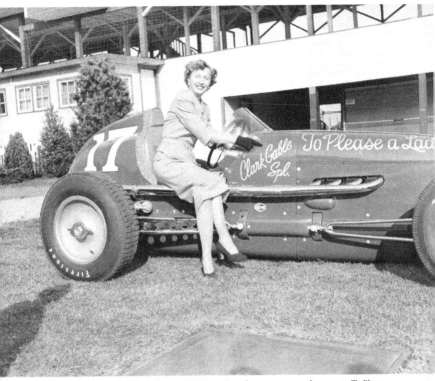

Barbara Stanwyck appeared at the Indianapolis Motor Speedway to promote her movie *To Please a Lady*. Clark Gable also starred in the 1950 Metro-Goldwyn-Mayer release. The film's climactic scene was shot at the Indianapolis Motor Speedway, which allowed Stanwyck to give the real 1950 Indianapolis 500 winner, Johnnie Parsons, a kiss in the victory lane. Indiana-born actor Will Geer also appeared in the movie. (Courtesy of Indiana Historical Society.)

In 1959, Ann Lawrie was selected as the first ever 500 Festival Queen. Lawrie was chosen out of a group of 32 candidates. She attended Sacred Heart School in Indianapolis before studying at the St. Vincent Hospital School of Nursing. (Courtesy of Indiana Historical Society.)

In 1959, thirty-two candidates for the 500 Festival Queen posed for this photograph at the Indianapolis Athletic Club. To be eligible for queen, the candidates needed to be single and between the ages of 16 and 21. This was the third annual 500 Festival and the first year it had a queen. Four finalists were Kay Sims (back row, center), Jeannie Sinnock (to right of Sims), Joni Tischer (back row, fourth from left), and eventual winner Ann Lawrie (second row, second from right). (Courtesy of Indiana Historical Society.)

BEHIND THE SCENES

This is the cover of the souvenir program for the 500 Festival in 1961. The theme of the festival was "50 Golden Years," and it was chaired by P. Waldo Ross. The 500 Festival Queen in 1961 was Diane Barth, and Lt. Gen. Joseph W. Kelly served as grand marshal of the parade. (Courtesy of IUPUI Library.)

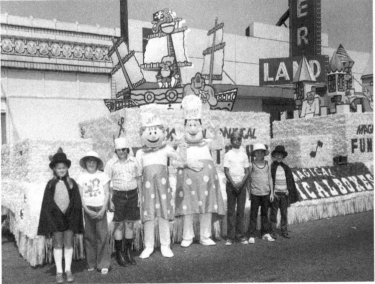

Burger Chef and Jeff pose with costumed children in 1975 in front of Rollerland roller rink at 922 North Pennsylvania Street. Burger Chef's float for that year's 500 Festival parade was titled "Magical Musical Boxes." (Courtesy of Indiana Historical Society.)

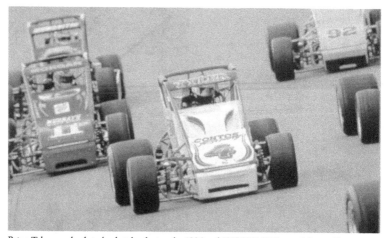

Brian Tyler won back-to-back titles during the 1996 and 1997 USAC National Sprint Car seasons. Tyler drove a car owned by Contos Racing of Anderson. Over the course of many years, Contos Racing owner Larry Contos scored big wins in Cedar Rapids, Idaho; Louisville, Kentucky; Du Quoin, Illinois; and Richmond, Virginia. (Courtesy of the Contos family.)

Larry Contos (right) is pictured with 1988 Little 500 winner Bob Frey (left) and Miss Little 500 Dana Ausbun. In 1988, Pay Less became sponsor of the Little 500 and created the Little 500 Festival. Contos attended the Indianapolis 500 at an early age and became a lifelong race fan. His love for auto racing led to him starting his own racing team that competed throughout the Midwest. Contos passed away in 2018 at the age of 77. (Courtesy of the Contos family.)

Pictured here is a promotional poster created by Madison County artist Patrick Kluesner for the 1994 Little 500 Festival. The festival was sponsored by Pay Less Supermarkets and included the Little 500 race, an antique car show, a baby-crawling contest, and events at the Historic Paramount Theatre. (Courtesy of Patrick Kluesner.)

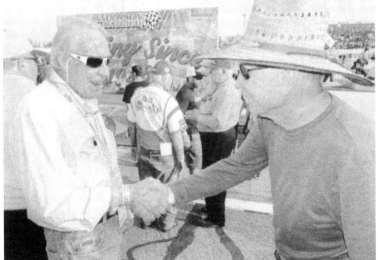

Larry Contos (left) is pictured with driver Jim Childers, who won the Little 500 in 1992, 1994, and 2000. Contos was the longtime owner of Pay Less Supermarkets in Anderson, Lafayette, and Muncie. In the 1980s, Pay Less sponsored cars at the Indianapolis 500 with drivers Arie Luyendyk, Pete Halsmer, and Tony Bettenhausen. Lafayette, Indiana, native Halsmer competed in the Indianapolis 500 in 1981 and 1982. (Courtesy of the Contos family.)

The Indianapolis Motor Speedway Museum is pictured here in the 1970s. The museum dates back to 1956 and was relocated to its current building in 1976. Dozens of winning cars from the Indianapolis 500 are on display in the museum along with the Borg-Warner trophy, photographs, and paintings. The museum is located in the infield of the Indianapolis Motor Speedway racetrack. (Courtesy of Indiana Historical Society.)

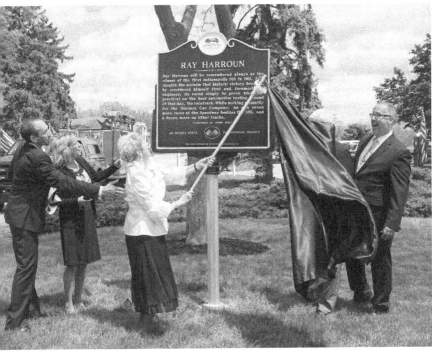

A memorial marker for Ray Harroun was dedicated on May 1, 2016, at Anderson Memorial Park Cemetery. Harroun won the inaugural Indianapolis 500 in 1911 and lived in Anderson until his death in 1968. He is interred at the cemetery on the city's south side. This memorial marker was sponsored by the Indiana Racing Memorial Association. In this photograph, Barbara Sherlin, Ray Harroun's granddaughter, pulls off the black covering to unveil the marker. (Courtesy of the *Herald Bulletin*.)

Visit us at
arcadiapublishing.com

CPSIA information can be obtained
at www.ICGtesting.com
Printed in the USA
BVHW051431250122
627119BV00004B/402